ON DIVAS

Persona, Pleasure, Power

SPENCER KORNHABER

zando

NEW YORK

CONTENTS

INTRODUCTION

———

SOMETIMES I WONDER WHY I, a man with no singing talent nor sequined garments, have written so regularly about divas, the sort of people—typically women—who cake themselves in fabulosity and perform for the stadium rafters. Then I remember that when I was a little kid, my favorite album was called *Diva*. It was the 1992 solo debut by Annie Lennox, previously the androgynously cool front woman for the Eurythmics, reinventing herself as a pop star in the Madonna mold. I must have been around five years old. I would study the album's cover, which showed Lennox pouting from beneath a red, feathered headpiece. I would dance on my parents' coffee table to the music: big-hearted synthpop with smooth, majestic crooning. I clearly loved theatricality, femininity, and happy sounds. Until, when I was a little older, I didn't.

Or at least I thought I didn't. My teenage and college years were spent immersed in moody rock music by men. The *Diva* days became a repressed memory, a childhood embarrassment. Only after the existential reckonings of early adulthood did I get back in touch with the side of me that could appreciate glitz and pretty melodies. What I'm

trying to say is that I came out of the closet. And by then I was working as a music journalist.

My suspicion is that everyone loves divas in the same way that everyone loves butter and salt or a 72-degree day. But unlike many of life's easy joys, pop music comes with baggage. Songs travel invisibly into the ear to trigger unstoppable feelings—but imagery, identity, and culture shape what we do with those feelings. Society often says that pleasure and self-expression are suspicious things. Only women and children, the people who allegedly don't run the world, can "waste" their time with dress-up and sing-alongs. But, of course, the yearning for freedom and ecstasy drives us all. Anyone can have a mundane grocery trip turn transcendent by hearing a Whitney Houston song.

The definition of *diva* is fuzzy, and this collection of essays and celebrity profiles construes the term very broadly. The one rule is that divas are in touch with what they want and will not apologize as they pursue it. Some of the subjects here—say, Beyoncé, Björk, Jack White, and Donald Trump—may seem to have very little in common, but all have cut a trail through the collective consciousness with fiery desire, creating new cravings on a mass scale, courting disapproval and controversy in the process.

A few other criteria are in the mix, too. Divas present an individualist fantasy, disguising how much collaborative

A

artifice it takes to wow a planet: makeup, hair, songwriting committees. The notorious "diva mentality," rude and righteous, is a by-product of the willfulness that makes these performers successful. Because public self-expression always invites scrutiny and jealousy, divas' downfalls are treated as spectacles as much as their rises are. Women have tended to play the role because it entails the sort of vulnerability and visuality that men are discouraged from partaking in. But anyone can act a diva if they have the guts.

Each piece in this book, written between 2016 and 2022, was shaped by specific times and circumstances. Which means that some expectations created by the title *On Divas* will go unfulfilled. This book does not trace how the diva concept derives from opera. Nor, unfortunately, does it contain a genealogy of the Black women—the Bessies, Arethas, Tinas, and Lizzos—who have done more than anyone to innovate upon the diva paradigm. I do not deconstruct Beyoncé's famous claim that the "diva is a female version of a hustler," though a lot of these articles are basically saying just that.

And because pop culture is always changing, so are the contexts for these stories. The opening essay about Britney Spears's conservatorship was, for example, written before she began angrily speaking out against her captivity and won her freedom in a 2021 court decision—though, in many ways, the tensions around her situation remain the ones I described. My 2017 interview with RuPaul about

his TV show's post-Trump awakening seems both quaint and prescient now that demagogues have targeted drag queens as part of a campaign to roll back queer acceptance. And were I writing about M.I.A. today, I'd note that her attention-getting tactics have been absorbed into the playbook of the dangerous conspiracy theorists with whom she started aligning herself in the past couple of years.

But the thing about the diva archetype is that it endures. This book's first section, "The Singers," is made up of character studies, concentrating on individual careers, but it's also about lineage: the way that certain desires and struggles seem to be passed down from one generation of performer to the next. Without Kate Bush upending expectations for female artists in the '70s and '80s, we don't get Björk doing so in the '90s and 2000s, and we maybe don't get figures such as SZA or Billie Eilish doing so today. Without so many pop listeners having lived through the emancipation of Mariah Carey, the #FreeBritney campaign might have gone differently.

Divadom evolves, too. Section two, "The Stage," leans toward cross-cultural criticism, noting how voices can harmonize into trends, and asking whether the role of the diva is changing in our advanced era of social media. Platforms such as TikTok are making celebrities feel smaller, more custom. But they are also democratizing diva aesthetics, turning the act of singing into a hairbrush

A

while stepping to an eight-count into social currency. I am very thankful that smartphones and the internet weren't around to spectate my coffee-table choreo. Yet had I known there were many other kids like me, maybe I'd have come quicker to the diva imperative: It's just more fun to be who you are, and loudly.

SPENCER KORNHABER

April 2023

I

THE SINGERS

THE EMANCIPATION OF
BRITNEY SPEARS

October 2020

SOMEDAY, WITH LUCK, Britney Spears will write a "good, mysterious book." At least, that's what she said in the closing moments of *Britney: For the Record*, a 2008 MTV special that capped off a few years of highly publicized turmoils for Spears: paparazzi skirmishes, child-custody battles, lethargic performances, an involuntary psychiatric visit, and one infamous head shaving. The documentary captured the singer's attempt to move on from her scandals, but at the end of its hour-long running time, an interviewer noted that Spears had still discussed her problems in only vague terms. With a wistful smile and tilt of her head, Spears assured viewers that she'd eventually put all her answers in writing.

People who track down *For the Record* today—despite its absence from streaming services, official retailers, and even most bootleg sites—may be searching for clues to a mystery that still surrounds one of the world's most famous people. In January 2008, the then-26-year-old Spears was committed to a hospital psychiatric ward

against her will, and her father, Jamie, obtained tempo-rary legal control of her affairs. She could no longer make her own appointments, go for impromptu drives, or freely use the millions of dollars she had earned since coming into superstardom at age 16. Spears initially tried to con-test the arrangement—known as a conservatorship—in court, but a judge had determined her mentally unfit to choose her own attorney. By the time of *For the Record*'s November broadcast, the conservatorship, overseen by Jamie and a lawyer named Andrew Wallet, had become permanent. Spears had settled into what she called a "bor-ing" new life of constant monitoring by doctors and law-yers. "Even when you go to jail, you know there's the time when you're gonna get out," she said in the documentary. "But in this situation, it's never ending."

It was a shockingly quiet end to what had been a rau-cous story. Throughout her rise, Spears presented herself as the archetypal young girl rebelling into womanhood: a 16-year-old Catholic student shimmying provocatively in her school halls, a 19-year-old party animal complain-ing of being so *oh-oh*-overprotected, a newly married 22-year-old singing that she didn't need anyone's permis-sion to make her own decisions. The way her performances jibed with her at-times-wild personal life proved irresist-ible to the early 2000s' unchecked gossip media, which magnified her every sartorial, romantic, or parenting snafu. Then, in 2008, Spears—a twice-married mother of

two—became someone who really did need permission to make any significant decisions. Her next album, released later in 2008, was called *Circus*, but Spears's publicity circus had definitively ended.

For the Record would be the last time she'd openly discuss the conservatorship. In the years since then—years that have seen multiple smash singles, sold-out world tours, and a Las Vegas residency—Spears's handlers have tightly controlled what gets asked of her in interviews. They've also kept most of the court documents related to her situation sealed. Whatever medical condition supposedly prevents her from being able to handle her own affairs remains publicly unknown. Her upbeat but inscrutable Instagram feed —a parade of selfies, dancing videos, and inspirational memes—gives no clear insight into whether she yearns for more control. A 2016 *New York Times* investigation surmised that "the conservatorship has become an accepted fact of life—not a cage but a protective bubble that allows her to worry about her true passions: music and her children."

Yet signs of trouble have become visible in the past two years, beginning with Spears abruptly canceling a second Las Vegas residency, announcing an "indefinite work hiatus," and making a stay at a mental-health facility. In the fall of 2019, Jamie temporarily left his role as conservator, citing his own medical crisis, and a woman named Jodi Montgomery—who had been working as Spears's

health-care manager—took his place. Spears then, in an August 2020 filing by her court-appointed lawyer, expressed a desire for her father *not* to return to his role as conservator. She instead wants Montgomery and a financial firm to handle her affairs. A legal skirmish has unfolded, with Spears's representatives accusing Jamie of financial mismanagement and repressive secrecy, and Jamie firing back with accusations of grandstanding and recklessness.

The court drama has thrown gasoline on a long-simmering fan movement called "Free Britney." Its slogan encompasses a range of beliefs based on information of varying credibility, but its adherents all generally see Spears's conservatorship as an injustice. Some fans simply think the singer deserves more autonomy as an adult who has capably performed in concerts, TV shows, and interviews over the past 12 years. Other fans, who comment on the star's every social media post, worry that she has been gaslighted, blackmailed, or—here's one for your 2020 bingo card—killed and cloned by the global elite. Followers have protested outside her in-person court appearances, interrupted Zoom hearings, and hounded members of Spears's family for info. They have also combed through legal records, circulated unverified and allegedly leaked documents, and scrutinized Spears's Instagram photos for signs that she's being held hostage. In doing so, the fans have themselves become controversial.

"All these conspiracy theorists don't know anything," Jamie told the *New York Post* in early August. "The world don't have a clue. It's up to the court of California to decide what's best for my daughter. It's no one else's business." For a while, Spears appeared to agree with that assessment. A message posted to her Instagram while she was in a rehab facility last year asked for privacy for her and her family members. Subsequent Instagram posts have bristled at fans' insinuations that she is not in charge of her own social media accounts, and she has shared images and captions asserting herself as healthy and content with life.

Yet in August, the Free Britney movement seemed to receive vindication. "Britney welcomes and appreciates the informed support of her many fans," wrote Spears's lawyer, Samuel D. Ingham III, in a court filing. Also in the document:

> Britney's conservatorship has attracted an unprecedented level of scrutiny from mainstream media and social media alike. Far from being a conspiracy theory or a "joke" as James reportedly told the media, in large part this scrutiny is a reasonable and even predictable result of James' aggressive use of the sealing procedure over the years to minimize the amount of meaningful information made available to the public . . . Transparency is an

essential component in order for this court to earn and retain the public's confidence with respect to protective proceedings like this one. In this case, it is not an exaggeration to say that the whole world is watching.

Although Spears wants substantial changes to her life, the conservatorship, Ingham writes, is "voluntary," and she is currently not looking to end it. Lawyers will be in court again this month to discuss the case, and if Spears's side gets the "transparency" that it is asking for, the issue of her independence—and the question of why she does not have it—will be litigated more publicly than ever before. Fans, clearly, would be thrilled to learn more about what's been going on with their idol. But if greater public attention solves more problems than it creates for Britney Spears, it'll be the first time.

THERE IS NO PRECEDENT FOR Spears's situation in its particularities. But the slogan "Free Britney" evokes a rich lineage of pop stars, especially female pop stars, struggling for self-sufficiency in public—and the public has typically been cast as an ally and sympathetic witness in such struggles. Only a few years ago, fans popularized the catchphrase "Free Kesha" after the singer filed a lawsuit alleging sexual abuse and manipulation by her manager and producer, Dr. Luke. (He denied her claims and eventually

A

prevailed in a court battle over her record contract.) A little more than a decade before that came a "Free Fiona" campaign seeking to liberate Fiona Apple from a suffocating record contract. Taylor Swift recently sicced fans on execs she alleged were holding her catalog hostage. Janet Jackson's 1986 breakthrough, *Control*, commemorated the banishment of romantic, familial, and financial manipulators from her life. When Beyoncé ejected her father from the role of her business manager, too, it became a pivotal chapter in her ongoing public narrative.

These women's stories differ, but taken together, they seem to confer lessons about exploitation, fame, sexism, and the capacity to transcend those things. Humming along to songs of freedom and reading *People* stories about power struggles, the casual consumers inevitably get invested.

Arguably the most potent of the pop-liberation narratives to date comes from Mariah Carey, who just released her own "good, mysterious book" that can't help but call to mind the Free Britney saga. The public is already familiar with Carey as someone forever declaring independence, whether when singing "I Am Free" in 1995, presenting herself as an un-cocooned *Butterfly* in 1997, or celebrating *The Emancipation of Mimi* in 2005. *The Meaning of Mariah*, a memoir co-written with the journalist Michaela Angela Davis, movingly fills in the substance behind Carey's inspirational belting. Growing up on Long

Island as the daughter of a white mom and a Black father, Carey spent her early years in a kiln of racism, classism, and violence—much of which was inflicted by her own family members. Her singing allowed her to escape those circumstances, but the hugely successful career that unfolded did not, for a long time, bring Carey personal autonomy.

The middle section of *The Meaning of Mariah* is devoted to what she describes as a torturously controlling relationship—an informal conservatorship of sorts—with the former Sony Music executive Tommy Mottola. They met when she was just 18; his company released her debut album when she was 20; they married when she was 23 and he was 43. She refers to the mansion they built together as Sing Sing, after the upstate prison of national infamy. She writes of cameras, intercoms, and security guards monitoring and regulating her every move. She writes of feeling like her creative decisions were never fully her own. "I couldn't talk to anyone that wasn't under Tommy's control," Carey writes. "I couldn't go out or do anything with anybody. I couldn't move freely in my own house." Perceptively, she adds, "Captivity and control come in many forms, but the goal is always the same—to break down the captive's will, to kill any notion of self-worth and erase the person's memory of their own soul." (Mottola's take on the relationship, in a 2013 memoir: "If it seemed like I was controlling, let me apologize

again. Was I obsessive? Yes. But that was also part of the reason for her success.")

How'd she get out? Other people. Therapists, collaborators, and friends helped her realize that her situation was not normal. So did fans. Carey shares a baffling memory of going to play a concert in 1993—well into her career, with a fistful of No. 1 singles to her name—and being confused to see crowds of people behind police barricades in the streets. For years, she says, Mottola had whisked her between industry gigs and their secluded home, preventing her from encountering the masses of listeners who'd become her diehards. "Here I was again, about to hit another stage, and somehow I had no clue that I was famous," she writes. "Because I was never alone, I had no comprehension of the impact my music and I were making on the outside world . . . Did Tommy know I would be easier to control if I were kept ignorant of the full scope of my power?"

Even after Carey walked out on Mottola in 1997, she continued to feel oppressed by close figures in her life. In 2001, Carey, suffering from exhaustion amid back-to-back video shoots, flipped out at her mother—and her mother called the cops. The incident ended with Carey temporarily committed to a mental facility, a development that titillated the tabloids. In Carey's telling, her mom—whom she generally portrays as selfish and manipulative—overreacted and gave the paparazzi what they wanted: the

public image of an erratic diva in need of being monitored and subdued. Carey also suspects that her mother and her brother wanted to use her mental exhaustion as a pretext to seize control of her business affairs. The story casts Carey's relatives and the tabloids at large in the role of jailer—but today, she has a potent shield against them.

"I still feel part of the media are patiently waiting for me to have another spectacular meltdown," Carey writes, "but the difference is, in today's world, *they* don't matter. Now, all artists have an unfiltered voice and enormous public platforms through social media . . . Our fans can come to our defense, bring all the receipts, and create a united front."

CAREY'S PORTRAYAL OF POP FANS as heroic, receipt-wielding defenders of their divas may well be inspiring to the Free Britney campaign. A TV performer since age 11 and a pop celebrity since age 16, Spears has scarcely known a life outside of privacy invasions by the masses. Her fans, while theoretically part of such masses, have long viewed themselves as her guardians. Before Free Britney, after all, there was "Leave Britney Alone," the famous 2007 cry of a fan on YouTube fed up with prying paparazzi and pundits.

Now fans are attempting to harness the media for her protection. In April 2019, the hosts of a podcast called "Britney's Gram" shared a voicemail left by an anonymous source who they said was formerly a paralegal at a

A

firm involved with the conservatorship. The source alleged that Jamie had forced Spears into a mental-health facility last year, which would contradict the official narrative that Spears had voluntarily sought treatment. "Stans, if there's one thing we know, it's the internet," Tess Barker, one of the podcast's hosts, said after playing the message. "We need to get this so public, the opinion needs to shift to where there is no choice but to do right by Britney Spears."

The tense irony of the situation is that these self-styled saviors are pitted against people who have been Spears's legal guardians—the people who are now asking for Spears to be left alone. Jamie has sued and allegedly threatened fans who have inveighed against the conservatorship. Jamie Lynn, Spears's younger sister—who was recently named the trustee of Britney's estate—has, on social media, asserted her family's need for privacy. Such rhetoric raises the disturbing thought that the Free Britney movement merely re-creates the same voyeuristic pressure and prying that tormented Spears early in her career. But with Spears's lawyer now saying that the star welcomes the informed support of fans, the picture seems different. She seems to be inviting help.

Indeed, Spears's explicit lobbying against her father's control of the conservatorship feeds into the public's pre-existing ideas of who the villain is in her would-be emancipation narrative. "Me and my daughter's relationship

has always been strained," Jamie said in a 2019 court appearance; "I don't understand how he can be such an asshole, and then be so nice," Spears quipped after he walked out of the room in *For the Record*. More worrying was an incident last year in the home of Kevin Federline, Spears's ex-husband. Allegedly, Jamie broke through a door and intimidated Sean Preston, one of Federline and Spears's sons. Although police investigators found no evidence of abuse, Federline filed for—and was granted—a restraining order to keep Jamie away from their two sons.

The ugliness of that particular incident—an allegedly traumatizing moment involving minor children—is a reminder of some of the deeper stakes underlying Free Britney. Spears's first involuntary hospitalization in 2008 took place after she'd locked herself in a bathroom with one of her sons and refused to give him over to Federline, who by that point had been awarded full custody of their children. In the years since then, she regained a 50/50 custody split. But after his 2019 restraining order against Jamie, a new agreement gave Federline 70 percent custody—and Federline's lawyer says that in reality, he is with the children "closer to 90" percent of the time. It's not unreasonable to wonder whether Spears's newly overt campaign against her father's control is, in part, a bid to see her kids more.

The fact that Spears's children are at issue is another reason an overly zealous public-pressure campaign against

the conservatorship could be dangerous. On an Instagram live-stream conducted earlier this year by Spears's 14-year-old son, Jayden, viewers got him to trash-talk his grandfather. They also pushed him for info about his mother's health and legal situation, and Jayden replied that he'd open up about her once he reached 5,000 followers. To hound a child for gossip about his mother is a funny way of helping that mother—and shows how parts of Spears's fandom haven't learned the most glaring lessons about their idol's struggles with fame. In the same podcast episode in which she called for listeners to organize en masse against the conservatorship, Barker attempted to draw a line between the helpful and unhelpful attention one can pay a celebrity in distress. "I hope we've learned," she said, "in the ideal situation, where she gets her freedom, let's leave her alone."

FANS SHOULD ALSO BE AWARE of the psychological complexities that a straightforward emancipation narrative cannot account for. On this topic, too, Mariah Carey's example is instructive. In 2018, she announced that she'd been diagnosed with bipolar disorder in 2001, thereby triggering an outpouring of sympathy and understanding from the public. Yet nowhere in the 368 pages of *The Meaning of Mariah* is the word *bipolar* mentioned; nowhere is there discussion of a diagnosis, or a thought on how it shaped her life. "I don't feel like there's a mental-illness discussion

to be had," Carey told *Vulture* when asked about the omission. "It is not to deny that. I am not denying that. I just don't know that I believe in any one diagnosis for a situation or a human being." Carey today casts her own life as a tale of overcoming circumstances via willpower, faith, and the support of fans—but it's surely more complicated than that.

Spears's medical matters should by all rights remain private unless she chooses to talk about them. But with Spears's lawyer seeking more transparency in court proceedings, the public may learn that the unfolding story is more complex than it seems. How will people react if the story they're so invested in is revealed to be one about not literal independence, but simply caregiving modifications?

After all, theoretically impartial doctors and judges have seen it prudent that the arrangement remain intact since 2008. Over the years, Spears has talked about grappling with deep social anxiety, and in one 2013 special, she made a possibly joking comment about having bipolar disorder. ("It's almost like it's my alter ego when I get on stage . . . I turn into this different person, seriously. Bipolar disorder.") If Spears ever writes—or is allowed to write—her "good, mysterious book," she may shed light on the ominous family statements, alarming media rumors, and odd public appearances that have all been invoked to justify her conservatorship.

For now, she continues communicating via social media, the tool that Carey says helped her take control of her own life. On Instagram, Spears has taken to posting strangely similar collections of pictures in which she is standing alone, facing the camera, and giving a pursed-lip smile. She'll also sometimes post videos of herself speaking in a chipper, hyperspeed flurry. Some fans believe she is sending a secret message, one that indicates she is being held captive against her will. The more obvious takeaway is that Spears interacts with the world differently than most people do—and that she's someone who's aware of the eyes on her, but never free of them.

BJÖRK IS BUILDING A MATRIARCHY

September 2022

———————

MIDDAY ON A MONDAY IN Iceland's capital of Reykjavík, Björk walked into a coffee shop and gave me a riddle. Just that morning, our interview had been rescheduled to an hour earlier than originally planned so that we could travel to a location unknown to me. Upon arriving at the plant-filled café where we'd agreed to meet, Björk thanked me for my flexibility. "We had to set our clock to the tide," she said, brightly, as if I would know what that meant.

Björk looked very Björk, which is to say that she looked like no one else on this planet. Her Cleopatra hairstyle had been dyed with strips of white, pink, and mold blue, and the pendulous ruffles of her gown-like overcoat were patterned orange and gray-green. The whole look read as fungal chic, reflecting the earthy aesthetic of her new album, *Fossora*, which will be out at the end of this month. But she moved through the busy café unbothered, even un-stared-at, by the other patrons. "Icelanders," Björk explained, "are too cool for school."

Yet at age 56, having spent three decades as one of music's most important figures, Björk has hardly gone

unnoticed in her home country. When I checked into my hotel in Reykjavík—a city of 135,000 that blends the vibes of a mountain-climbing base camp and a bohemian port—a song of hers was playing in the lobby. The Icelandic Punk Museum, a tiny labyrinth in a converted public bathroom, is partly a shrine to The Sugarcubes, the rock band that brought Björk to international fame in the late '80s. At a nearby bar, I got to chatting with a middle-aged man who said that Björk had babysat him when he was a kid.

Her influence is also inescapable worldwide. Starting with her 1993 solo album, *Debut*, and continuing through her acclaimed work of the past decade, she has carved a path with her guttural voice and counterintuitive melodies, her edgy instrumentation and wise lyrics, her surreal visuals and alchemical tech. Many observers have been confused by this brew, but for others, Björk is a comfort, an affirmation of their own inalienable originality. Today's forward-thinking female and queer stars—as varied as Rosalía, SZA, Solange, Perfume Genius, and Lizzo—tend to salute her as a foremother. In Billie Eilish's glamorous grotesquerie and hyperpop's chipper chaos, you can see a surging interest in Björk's longtime quest: proving supposedly soft qualities—vulnerability, caring, wonder—to be forms of guts and brawn.

Björk's new solo album is her 10th, and the round number is apt for a moment in which she's taking stock of

where she has come from and what she's accomplished. Her new podcast, *Sonic Symbolism*, revisits the creation of each of her albums. *Fossora* addresses legacy and ancestry in a different way, with some of her most vivid songwriting and most daring arrangements to date. As velveteen-sounding woodwinds respire amid hard beats, Björk examines her place in a lineage of nurturers, peacemakers, and problem solvers. In our four hours together, she described the workings of "matriarch music"—a term that defines both Björk's ethos and a broader, now-strengthening current in pop culture.

First, though, we had to talk about actual currents. Björk's secret plan was for us to head to the Grótta lighthouse, located on a black-rock point northwest of Reykjavík. She has periodically gone there to record music, and when the tide gets high, it becomes unreachable by foot—which is part of the fun. "Sometimes you're working on a song for a few hours, and it's like, either I leave now or I work six more hours on it," she said. "You have to choose."

Her assistant drove us to the beach parking lot, and then we made a trek past volcanic pebbles and fragrant kelp deposits. The August day was typical for Icelandic summer—mid-50s and sunny. But the wind blew ferociously, flattening the coastal grass, undulating the fronds of Björk's coat, and contributing to my sense that we were marching to a portal at Earth's end. As we approached a

A

stout white tower, Björk let out a sigh: "Ah, yes! The feeling."

Our destination turned out to be not the actual lighthouse, but a building near its base. Her assistant unlocked the door, revealing a tall-ceilinged meeting room with blondwood beams and a blue-tiled kitchenette. This was, to my eye, a neat-and-tidy lunch spot for science class field trips. But to Björk, it was layered with history: Masterworks had been made here; friends had slept here; birthday and Christmas parties had been thrown here. The location's mix of untamed exterior and orderly interior came to feel very Björk too. As we began discussing her music and the world it reflects, a high, faint *whoosh* sounded through the room. "*Yessss*, you'll get the Icelandic wind on your recording," she said, interrupting herself. She then tilted her gaze to the universe. "Thank you!"

NATURE ALWAYS BLEEDS INTO BJÖRK'S WORK, and *Fossora*'s emotional landscape is inspired by the mushroom kingdom. But, Björk emphasized, she wasn't thinking about the red-and-white toadstools of children's cartoons. "Elves and all that sort of shit, [people have] really tried to throw on me for my whole career," she said, referencing portrayals of her as a Peter Pan–type figure, naive and mystical. *Fossora* channels "the adult, sensual, delicate side of fungi, where they act like nervous centers for forests," she said. "Like, that sort of techno energy."

Connection, rootedness, delirium—these feelings ruled Björk's early COVID-19 days, which she spent at home in Iceland, playing living-room DJ sets for her buddies. For a world-touring musician from an island nation with low infection rates, forgoing travel meant finally enjoying "a village life," she said: "Wake up, walk to a café, meet your friends, go to the swimming pool." To evoke this coziness in song, she asked a sextet of bass clarinetists to imagine they'd drunk "one and a half glasses of red wine—not more" at some northern Scandinavian jazz bar in the year 2050. On some tracks, she added percussive outbursts that sound like a board getting hammered hundreds of times a minute.

What Björk really loved about pandemic-pod life was that "you went further with each friend or relative—you went deeper." *Fossora* goes deep, startlingly deep, in the same way. Her two grown-up children sing on the album, and two tracks address her mother, who died in 2018 at age 72. A number of songs celebrate some unknown sweetheart ("his capacity for love is enormous!"). Björk's music has always had a personal side, but a mineral vein seemed to open in her songwriting with 2015's *Vulnicura*, a wrenching masterpiece about her breakup from the artist Matthew Barney. Now she delves into her identity as a daughter and a mother.

That Björk has been a parent since before she was internationally famous has been a key, if sometimes

misunderstood, part of her story. In 1986, as the 20-year-old singer for an underground punk band, she caused outrage in Iceland by performing on TV with her pregnant belly exposed. She bore her son, Sindri Eldon Þórsson, on the same day that The Sugarcubes formed (the guitarist was his father). When she famously attacked a journalist in Thailand in 1996, she said it was because the reporter had been pestering her kid. Another legendary incident, in which she wore a swan-shaped dress and dropped eggs on the red carpet at the 2001 Oscars, was intended as a statement about fertility. The following year, she gave birth to her daughter, Ísadóra Bjarkardóttir Barney.

The media and listening public have rarely been respectful to entertainers who are young mothers—the 2007 implosion of Britney Spears's image, for example, was linked to scrutiny of her parenting (Björk wrote Spears a sympathetic letter around that time). But Björk said that she never felt much tension between being a musician and being a mom. When she went on the road with The Sugarcubes, she reasoned that young Sindri would either love traveling or not—and if he didn't, she recalled thinking, "I'll just write my own music and live in a lighthouse or something." Her bandmates agreed to split the cost for a babysitter to come on tour, an accommodation that she credits to Iceland's family-oriented, remarkably women-led culture.

A sort of practical-minded inspirationalism, loving but steely, has long run through her work. You can hear it in her buck-up-and-stop-complaining sermons ("Army of Me"), celebrations of selflessness ("Pleasure Is All Mine"), and anthems about emotional intelligence ("Mutual Core"). *Fossora* makes these themes especially visceral, presenting love as a kind of labor. On "Victimhood," sampled fog horns conjure the murk of someone drowning in self-pity—a quality Björk used to pride herself on lacking. But she recently realized that she does tend to put other people's needs in front of her own and then feel bad about it. "It's a matriarch sort of problem," she said. "You have to just own it and say, 'Yes, I make this sacrifice.'"

With Ísadóra now 19 years old, *Fossora* finds Björk without a juvenile in her care for the first time in her career—a milestone noted in the album's moving finale, "Her Mother's House." "The more I love you, the stronger you become, the less you need me," she sings, and her daughter eventually replies, in a gracious lilt, with her own poetry. Björk gave Ísadóra a good amount of time to think about whether she wanted to be on the song: Björk feels that her own entry into the spotlight at age 11, via an album her mom and stepfather helped her record, was premature. But Ísadóra had already begun to pursue a career in the arts (both she and Björk acted in 2022's Viking epic *The Northman*). "She's like me in that she'd rather do a

few things and have them be precious," Björk said. "I'm very proud of her in that way."

Sindri's appearance on the album makes a statement as well. Last year, social media users disparagingly circulated a years-old statement in which he, an indie-rock artist, wrote that he was "a better songwriter and lyricist than 90% of Icelandic musicians, my mother included." He recanted, and Björk was surprised that people took what was obviously a joke so seriously. "I was actually thinking the other day, feeling for him a little bit," she said. At 36, and as a father himself, Sindri is a "very self-sufficient, very healthy, emotionally, individual," but sometimes he has been subjected to the assumption that "sons of successful women . . . must be losers or something," she said. "Well, it's total bullshit."

He lends his handsome voice to "Ancestress," a seven-minute, string-laden stunner about Björk's late mother, Hildur Rúna Hauksdóttir. Björk said she wrote it and the elegiac "Sorrowful Soil" as rejoinders to a centuries-old Icelandic song that lists the mere facts of a dead man's life ("how patriarchal," she said). Her songs, by contrast, form a "biological or emotional obituary," with impressionistic scenes: Hildur singing lullabies to Björk as a child, Hildur losing coherence on her deathbed. On "Sorrowful Soil," Björk and a choir sing, in a stammering cadence, "You did well." She said that's the message she tried to "squeeze"

into her cool-headed, compliment-averse mom in her final days.

But Björk did not really want to talk about her mother with me. For most of our interview, she'd spoken in tumbling sentences illustrated by decisive hand gestures, which caused the pleather-ish material of the kimono she wore under her coat to creak. A few minutes into discussing "Sorrowful Soil," her patter slowed to a crawl, and she drummed her fingers on the table. "My brain—it's like there's smoke coming out of my brain," she said. She asked if she could go to the restroom to clear her head.

When she returned, she explained that the other journalists she'd spoken with recently had grilled her about her mom, the subject of only two of *Fossora*'s 13 tracks. "People think this whole album is a grief album," she said. "I think you will get a more interesting article if we move on." So we did.

TO BE HONEST, I had wanted to learn more about Hildur, but mostly to understand what has long made Björk's worldview—and art—so hard to pin down. An activist who once went on a hunger strike to oppose industrial development in Iceland, Björk's mom had an uncompromising nature that, according to interviews Björk gave earlier in her career, caused her daughter to feel ambivalent about hard-core feminism. Björk has, over the years,

A

come to fully endorse women's empowerment—but *Fossora* makes clear that -isms still make her squirm.

The album's title is a feminization of the Latin term for *digger* or *miner*, and I wanted to know whether she'd chosen it to make a statement about gender. "Yeaaah," she said hesitantly. "I try not to talk too much about it, but pretty much the last 10 years, that's what I've been doing. I want balance. I love guys and alpha males and all that. I just want 50–50. The first half of my life, I was working more inside . . . y'know, I almost don't want to say it. It's so tired. But inside 'the patriarchy,' or whatever. And maybe not totally understanding it, because I was too young."

On *Fossora*, the search for nuance sounds urgent, even harrowing. The album's thunderous opener, "Atopos," features Björk singing, in an agonized tone, that "to insist on absolute justice at all times / it blocks connection." Its message is both personal and political, a call for fractured homes to work things out. I told her that in the United States, extreme partisanship has made compromise seem fantastical. "You start talking about each other's kids," she suggested. "What do you want for them? I think it's more about the future and where we're going. Take the heat off the moment, because it's unsolvable."

The song, she said, was also inspired by the fallout from #MeToo. She aligned herself with the movement in

2017, publicly alleging that she'd been abused on a film set earlier in her career. But she worries that name-and-shame campaigns don't always serve healing and compassion. "If you cancel everyone, that's not a solution," she said. "Especially with younger males, they have to have an opportunity to evolve and grow and learn."

Recent events have tested her on this issue. One of her prime collaborators on *Fossora* was the Indonesian experimental-dance-music duo Gabber Modus Operandi. An accusation of sexual assault that emerged online this summer led the band's emcee, Ican Harem, to issue a public apology and go on hiatus. Björk edited Harem's voice out of *Fossora*'s title track and removed shots of him from the planned "Atopos" video. But when we spoke, she was still debating whether to also scrub the album of the band's beat maker, Kasimyn, who wasn't accused of anything. "I want to have courage to be in the gray area," she told me. A week after our interview, the "Atopos" video premiered, featuring shots of Kasimyn DJing a freaky forest rave.

The forces that drove #MeToo are reshaping music culture in a more fundamental way too, Björk suggested. In a 2016 Facebook post, she lamented that society pressures female musicians to "cut our chest open and bleed about the men and children in our lives." She isn't worried about that expectation as much anymore, thanks to the past five years of women sharing their stories in public. On *Fossora*,

she freely moves between abstraction and confession, guardedness and revelation. "When you have a good moment in a song is when you overcome the contradiction between the universal and the personal—it becomes the same thing," she said. "That is the soft spot we are all craving."

Discussing the topic of emotional openness in song-writing, Björk brought up her lifelong fandom of Kate Bush, whose music has always had a "current of generosity" running through it. As a self-produced songwriter singing about her inner life, Bush "wasn't a guest in a guy's world," Björk said. "She *made* the matriarch world. All of it." The example Bush set went beyond lyrics: In the first episode of the *Sonic Symbolism* podcast, Björk cited Bush while tracing the way that synthesizers and drum machines have long been a haven for women and queer people alienated by macho rock and roll.

Of course, back in the '80s and early '90s, Björk pointed out, some male gatekeepers treated Bush as a "third-class loony woman." Many listeners, in turn, felt embarrassed to openly embrace her. So this year's world-wide resurgence of Bush's old hit "Running Up That Hill (A Deal with God)" may well represent a sweeping change. "Gen Zed, they have room for matriarch music," Björk said. "It's not like crazy witches, old ladies, [going] 'oooh'"—she made an appropriately spooky sound— "with cats and on brooms."

She sees appreciation for matriarchy elsewhere in music these days too, especially in the popularity of female rappers expressing themselves in fiercely feminine terms. But as for Björk's own cultural renown, she said that she tries to tune out most of the chatter about her. On the day that *Fossora* was announced, she did let herself peek at the reaction online. She couldn't believe the enthusiasm she saw for a clarinet-and-techno album about fungus. "I just felt really grateful that people really care," she said. "When it comes to people making an effort and understanding me, I think I've been pretty lucky."

After more than three hours on Grótta Island, the tide was coming in, and it was time to escape. We exited back into the wind, and Björk gave me a high five. On the walk, she said that she was glad we'd talked about "Ovule," a lurching, trombone-driven standout from *Fossora*. The song outlines her theory that we each carry three "eggs," filled with ideals, realities, and darkness. It is also about the way that Björk's view of human connection has morphed since her girlhood, when she dreamed only of fairy-tale romance. "You realize, as you get older, it's not so black and white," she had said. "Love is in lots more places. And it's just as strong. It just lives in other shapes."

WHY DRAG IS THE ULTIMATE
RETORT TO TRUMP

June 2017

RuPAUL CHARLES, America's most famous drag queen, sat on a gold lamé couch at a luxury hotel in Midtown Manhattan one Tuesday in March, doling out advice for the white working class. Wearing a patterned suit jacket and black slacks—one of his signature out-of-drag looks—he made a hand motion to suggest widgets being moved from one part of an assembly line to the next.

"If you were a factory worker and your job was to put this to this from 9 to 5, we don't do that anymore," he said, his soft voice carrying the imperious, jokey edge familiar to viewers of *RuPaul's Drag Race*, his reality-TV show. Then he referenced a viral video from Ts Madison, a transgender activist and former porn star: "You better step your pussy up. Get on a business, bitch!" He delivered this spiel with the clipped, decisive tone of a therapist on the clock. "Nature will not allow you to just sail on through doing some factory job," he said. "We don't do factories anymore."

At 56, RuPaul is in little personal danger of being phased out; he is, to the contrary, one of gay pop culture's

most enduringly relevant figures. Over the past quarter century, he has done more than anyone to bring drag to the American mainstream. At the same time, he has used his platform to act as life coach to the queer masses, counseling self-love and hard work to combat social stigma and inner doubt. (Catchphrase: "If you can't love yourself, how in the hell you gonna love somebody else?") But lately, thanks to political developments, this inspirational package has come with a dose of indignation, and a sharpened sense of social purpose.

In November, RuPaul tweeted that he was "finding it hard to carry on 'business as usual' after America got a giant swastika tattooed on her forehead," and he told *New York* magazine's *Vulture* website that Donald Trump's win felt "like the death of America." By the time I met up with him in March, right before the premiere party for *Drag Race*'s ninth season, his mood had improved considerably, but his focus was still on the political scene. "My optimism is back. I understand what it is we must do," he said. "We're going to mobilize young people who have never been mobilized, through our love of music, our love of love, our love of bright colors."

Such mobilization would seem to already be in progress, thanks to *Drag Race*. Tuning in is like entering a fluorescent cocoon of camp, where men who perform as women battle in a wild reimagining of *Project Runway*. Launched on Logo, Viacom's queer-focused network, in

2009, the show is ubiquitous in many gay-friendly circles; this spring, it moved to VH1, in a bid to bring drag to a wider audience.

The moment seems ripe for it. An ad for Season 9 features the tagline "Drastic times call for dragtastic measures" and RuPaul saying, "We need America's next drag superstar now more than ever" —the implication being that cross-dressing has taken on a special charge under Trump. Which isn't to say the show wasn't socially engaged before. In the Obama era, *Drag Race* cheered on gay rights and reveled in gender identity's vagaries just as gay rights were making significant gains and many Americans were beginning to grapple in earnest with transgender people's existence. Still, the rejection of a woman president in favor of a man who reportedly prefers his female staffers to "dress like women" and whose supporters rail against "cucks" and "the pussification of America" places drag in a more obviously defiant context: The pussification of America—the freedom of men to partake in that which society has marked as feminine and vice versa—is exactly what RuPaul wants.

The early months of the Trump presidency have seen drag flourish as a form of political critique. The signature pop-culture send-up of the administration has come not from Alec Baldwin's pursed-lip Trump on *Saturday Night Live* but from Melissa McCarthy's wild-eyed Sean Spicer—a parody of macho huffiness that reportedly

infuriated Trump because, a source told *Politico*, he "doesn't like his people to look weak." This reaction led some critics to call for *SNL* to drag up the entire administration; Kate McKinnon has since portrayed Jeff Sessions, and Rosie O'Donnell has offered to play Steve Bannon. Underscoring the sense of gender panic in Trumpland, one of early 2017's defining memes came when a conservative Twitter user added the words "This is the future liberals want" above a picture of a niqab-clad woman and a drag queen—two bogeyladies of the culture wars—sitting comfortably on one New York City subway bench. The fact that for many liberals this indeed was a perfectly lovely vision prompted much hilarity. One of *Drag Race*'s stars, a deranged-Russian-prostitute character named Katya Zamolodchikova, tweeted the same caption with a photo of herself crouching grotesquely in a green bodysuit and Birkenstocks.

RuPaul's own Twitter feed has become a steady source of GIF-laden jabs against the "Manchurian pumpkin," his preferred term for the president. *RuPaul: What's the Tee?*, the motivational and comedic podcast he co-hosts with Michelle Visage, a *Drag Race* judge, has begun devoting more time to current events. The title track of his new album, *American*, uses thumping dance pop to assert that gay Black drag queens are as American as anyone else. He's deejayed events to benefit Planned Parenthood and the ACLU in recent months. When I suggested that his

level of political engagement had increased, he replied that he'd long been outspoken about politics but not policies. "Now I've been happy to talk about policies," he said. "Because the world's gone batshit fucking crazy."

IN PERSON, RuPaul is very much the same self-possessed bald beanpole that *Drag Race* audiences have watched dispense advice and shade to contestants—except his freckles are more noticeable, and his shade can be turned on you. At one point, while discussing the virtues of transformation, he eyed my outfit and suggested that drag could teach the squares of the world to live a little, sartorially speaking: "When you think you've landed on this look with the black jeans and blue shirt for the rest of your life, we're here to say, 'You know, it's *just* clothes.'" (For the record, my pants were dark green.) As we talked, RuPaul seemed to be looking over my shoulder into the hotel lobby. He was, he explained, watching for his husband, Georges LeBar, who was on his way with a chicken panini.

The two married in January, partly out of concern that same-sex marriage could be rolled back under Trump. Though the wedding was in some ways a formality— they've been together for 23 years—it contributes to the sense that this is a time of personal flourishing for RuPaul. In a nod to his popularity (as well as to how absurd politics has gotten), John Oliver proposed on *Last Week Tonight* that the drag queen could run for president as the

progressive reality-TV-star retort to Trump (hypothetical slogan: "Make America fierce again"). In April, RuPaul debuted as a recurring character on the Netflix sitcom *Girlboss*, playing the main character's crotchety neighbor; J. J. Abrams is developing a dramedy based on RuPaul's years as a fixture of the New York City club scene.

The source material is rich. After a childhood split between San Diego and Atlanta, in the care of first his mother and later an older sister, RuPaul worked as an entertainer and shape-shifting party presence, donning loincloths and dabbling in David Bowie–esque androgyny while fronting the new-wave bands Wee Wee Pole and RuPaul and the U-Hauls. Eventually, he settled in New York. By 1993, he'd shellacked himself into the 7-foot-tall (in heels) "glamazon" character who rocketed to fame off the dance single "Supermodel (You Better Work)"; this, in turn, led to a talk show on VH1. Now *Drag Race* aims to subject less established drag queens to some of the same trials of "charisma, uniqueness, nerve, and talent" that he once faced. "My career has been built on the fringe of the status quo," RuPaul told me. "There was no blueprint for what I do."

Of course, drag as it's commonly practiced today did exist before RuPaul, mostly among queer folks whose pageants, any decent social theorist will tell you, delighted in exposing the artificiality of both femininity and masculinity. RuPaul's rise to stardom was part of a public

coming-out for the practice, which coincided with a wave of '90s-era drag-themed movies, including *The Adventures of Priscilla, Queen of the Desert* and the acclaimed documentary *Paris Is Burning*. Though the decade was a boon to his career, he thinks back with some frustration on various cultural gatekeepers who treated him more as a curiosity than as a social critic. He says he's always approached drag as "punk rock"—as an instrument of resistance. "Just being someone's punch line is not my idea of fun."

Today, even as he finds himself at new heights of acclaim, RuPaul sometimes feels that same sense of being misunderstood. Before a recent TV appearance promoting *Drag Race*, a producer asked whether he'd be willing to teach the show's host how to walk like a supermodel. The request offended him. "I'm not doing drag to give you makeup tips," he told me. "This has always been a political statement." That political statement doesn't exactly lend itself to specific action items, of course: RuPaul is as fluent in righteous woo-woo as any outspoken celebrity. "Following your heart is the most political thing you can do," he told me at one point.

Yet he seems sincere in his conviction that it is worth seeking out the deeper meaning of things that appear superficial. On a recent episode of *What's the Tee?*, he quizzed the actress Leah Remini on her acrylic nails and then, without pausing, asked, "I wonder what the subtext of having nails is? . . . Psychologically speaking, what's

underneath that?" And he seems equally sincere in his belief that lewd puns and piled-high wigs can fight everything from gender essentialism to consumerism. "Our culture is about choosing an identity and sticking with it so people can market shit to you," he said. "Anything that switches that around is completely the antithesis of what our culture implores us to do."

OUTSIDE *DRAG RACE*'S SEASON-PREMIERE PARTY, at the PlayStation Theater, in Times Square, the latest crop of contestants mugged for the cameras. Nina Bo'nina Brown wore facial prosthetics designed to resemble a gorilla; Jaymes Mansfield had on a *Muppets*-inspired bodice; Kimora Blac sported breasts evoking a pervy video-game designer's version of the female form. Though some of the queens talked up their "fishiness"—the joyfully crass drag term for seeming like a real woman—their outlandish getups illustrated one of RuPaul's central assertions: that drag's real purpose has less to do with passing for another gender than with highlighting gender's artificiality.

At one end of the red carpet, Sadie Gennis, a TVGuide .com editor, asked each queen to play a game of word association with some names: Oscar the Grouch, Emma Stone, Donald Trump. The responses to Trump's name were remarkable in their uniformity. Sasha Velour: "Already a horrifying drag queen." Eureka O'Hara: "Girl,

A

that hairline's a mess. You ain't never heard of lace glue?" Shea Couleé: "Girl, look how orange you fucking look, girl!" (The last line, which quotes a now-legendary *Drag Race* squabble about makeup, has shown up on anti-Trump protest signs.)

This notion of Trump as a drag queen is a common punch line, thanks not only to his Technicolor tan, bouffant hair, and love of insults, but also to his exaggerated display of masculinity. And yet when I put to RuPaul the idea that the president is a drag artist, he drew an important distinction: Trump "actually believes he is that thing. As drag queens, we know we're putting on a facade and we're always aware of it, which is what scares the status quo. He believes he looks good. He believes he's looking like a real man."

However visceral RuPaul's distaste for Trump, he isn't quite your typical Hollywood progressive. Yes, he thinks the guardians of straight white orthodoxy should lighten up, but he feels much the same way about, among others, liberal types who want him to apologize for casually dropping anti-trans slurs into his banter. Though RuPaul supports federal protections for transgender people and welcomes trans contestants on *Drag Race*, he can sound downright conservative when talking about the self-seriousness of liberal identity politics (he declines to describe himself as a liberal). And *Drag Race*'s cheeky

flirtation with gender and racial stereotypes—to say nothing of how it reappropriates terms like *bitch*—hasn't always rated as politically correct. "I'll make a joke about something and people will print it out and it sounds awful, when it's really clear my standpoint is 'Live your life, be free, do what you feel you need to do,'" he told me.

As the premiere party got underway, RuPaul appeared onstage, startling the sold-out house—the advertised lineup of performances by *Drag Race* personalities hadn't included his name—and received the loudest applause of the night, despite the fact that he was the only one whose outfit wouldn't have drawn a second look on the street. Introducing a clip of Season 9, he explained that the first episode would feature Lady Gaga. He turned to the drag queen Lady Bunny, a longtime friend. "We tried to get Lady Bunny [for the show], but she turned us down," he said, letting out a high, knowing laugh. "Lady Bunny, you are a whore."

The video that followed boasted much of the frivolity and bizarreness fans of the show have come to expect. The cast's first meeting quickly gave way to sniping about eyebrow shapes; one queen was done up like a voluptuous rodent. But the opening episode, which aired later in March, also reflected an engagement with larger issues. One contestant sobbingly told Lady Gaga that her career had helped save lives; another wore a leotard scrawled with #blacklivesmatter. Though the episode had been filmed

before November, it was not hard, watching it, to anticipate the turns that *Drag Race* might take in the future.

"This whole election thing was probably the best thing that could have happened," RuPaul had remarked to me earlier in the day, before leaving his hotel. "Because everyone is getting woke. These bitches are waking up."

BEYONCÉ'S *LEMONADE* AND
THE SACREDNESS OF SEX

April 2016

BEYONCÉ AND JAY-Z GOT ENGAGED on Jay-Z's birthday, and to celebrate, Beyoncé took her new fiancé to see naked women dance. At Paris's cabaret club Crazy Horse in 2007, she watched the synchronized striptease with a particular kind of awe. "I just thought it was the ultimate sexy show I've ever seen," she later recalled in a documentary, "and I was like, 'I wish I was up there, I wish I could perform that for my man.'" In 2013, she fulfilled that dream by returning to Crazy Horse to film the stupendously sexy music video for "Partition," a song about giving a blow job in a limo.

It's the kind of story from which you can pull a few competing narratives about Beyoncé—and about gender, sex, and pop music more broadly. From one popular angle, her co-ed cabaret celebration is a tale of empowerment: a tale of sex-positivity and feminism that bolster a traditional monogamous marriage. But from other angles, it's the opposite of radical: a story that's, at base, about women straining to please men. There's the meta reading, which points out the fact that superstars such as Beyoncé are like those Crazy Horse dancers writ large, shimmying

A

to the amazement and jealousy of a global audience. In almost any interpretation, you run into one of pop culture's abiding beliefs: Sex is power.

That belief has long been part of Beyoncé's art. So, too, has been the belief that hard work, profit, intelligence, family, love, God, friendship, fame, regional loyalty, Black pride, and awesome clothes are also legitimate ways to feel good and attain some degree of control over the world. Still, as is the case with many female stars, some people are unable to see anything but sex when they look at Beyoncé. Bill O'Reilly got mad about "Partition" for being too explicit. On the other end of the ideological spectrum, bell hooks called Beyoncé "a terrorist, especially in terms of the impact on young girls."

That sort of criticism might be harder to make about *Lemonade*, the album she released alongside an HBO film on Saturday night. It represents a landmark on a few levels—its release method, its racial politics, and its appearance of confessing to Jay-Z and Beyoncé's deep marital troubles. Under all of those things is an elaboration on the vision of sex that Beyoncé, filtered through popular culture, has often been seen to stand for—and that shift is reflected in the album's lush but comparatively less-than-immediately-gratifying sound. Here, being hot is not necessarily liberating. Sex is serious, sex can harm, and sex does not reliably do the things that society has said it can do. Feeling yourself is not enough.

FIVE SONGS INTO *LEMONADE*, there's a song called "6 Inch" that can't help but recall the Crazy Horse anecdote. It features a deep, electrifying bass line very similar to the one that powered "Partition," but the song itself is queasier and more Gothic. With the help of The Weeknd, Beyoncé salutes a stripper dancing in six-inch heels for money but not for "material things" nor, the implication goes, to appease any one man. Beyoncé likely sees her global pop-star hustle in this stripper's 24/7/365 labor, but the comparison with her personal life is murkier. After singing about a female performer's detachment from those she performs for, the goosebump-inducing outro has Beyoncé gasping for her lover: "Come back, come back, come back."

The album up until that point has obsessed over the idea that the fierceness of her body and brain should have secured her husband's loyalty as surely as it has secured her an unwavering fan base. The first song, "Pray You Catch Me," is a sonic sculpture of voice, strings, and piano, with Beyoncé weaving a wrenching melody as she describes feelings of mistrust. In the accompanying film, Beyoncé recites Warsan Shire's poetry about subjecting herself to total denial—of sex, of food, of mirrors—and still feeling the gnawing need to ask, "Are you cheating on me?" After she voices that question, she strides into a city street and begins wrecking shit with a baseball bat.

A

That demolition derby scene—yes, she drives a truck over parked cars—accompanies the album's second song, "Hold Up," a midtempo, reggae-influenced gem about every premise of Beyoncé's career being seemingly undermined. She "kept it sexy" and "kept it fun" and yet has still been betrayed. At one point, she raps, "I always keep the top tier, 5 star / Backseat lovin' in the car / Like make that wood, like make that wood"—a mishmash of references to previous Beyoncé masterpieces of raunch, including "Partition" and "Drunk in Love." The subtext is that her confident-and-sexy routines were in part about keeping her man mesmerized—and now it turns out, to her horror, they didn't fully work.

"Don't Hurt Yourself" brings in Jack White and samples Led Zeppelin to stir up blues rock over which Beyoncé howls about using her body's power for revenge. "You can watch my fat ass twist as I bounce to the next dick," she threatens. Then comes the electronic ticktocking of "Sorry," whose lyrics are anything but penitent: "Suck on my balls," she says. The playful melody that accompanies her call to flip the bird has the makings of a top-40 chorus, but there's a glassy-eyed distance to the song, a purposeful malaise. The accompanying video segment is labeled "Apathy."

The other side of "6 Inch" represents a turning point. With country guitar and jazz horns, "Daddy Lessons" spins a fable about a father who raised his daughter to be

tough—and warned her to avoid men like him. It's the start of Beyoncé taking a long view on her marriage, seeing it as part of a long tradition of damaged families. When men are told to betray women and women are told to perform for men, why would any one woman's efforts to perfect herself ensure a stable relationship? What is putting a ring on it next to historical forces?

The album's film, more explicitly than the album itself, roots this idea of emotional inheritance in Black identity. Malcolm X sermonizes about the disrespect paid to Black women, mothers show photos of sons killed by police, and Beyoncé vows that "the curse will be broken." The imagery on display proposes that progress will come from Black women drawing strength from one another and more Black men being made to feel themselves capable of living the kinds of lives that society has told them they can't live.

The songs themselves for the most part foreground a narrative about a personal struggle mastered through willpower, forgiveness, and discussion between wife and husband. The airy, fluttering "Love Drought" is a portrait of tentative reconciliation, with Beyoncé repeatedly trying to stow the nagging question of "What did I do wrong?" This is not about *I*—it's about *we*, working to "move a mountain." From there comes an arc of redemption: The shockingly raw piano ballad "Sandcastles," whose video features Jay-Z nuzzling Beyoncé; the uneasy sound collage

A

of "Forward," where James Blake's distorted voice personifies the muddle of co-dependence between fallible people; and the stomping gospel rock of "Freedom," in which Kendrick Lamar raps about the turbulent social backdrop against which the album's story has unfolded.

Sex finally resurfaces again on "All Night," the glorious summit before the celebratory "Formation" plays things out. The title itself evokes "Drunk in Love," the instrumentation is modern Motown, and Beyoncé alternates between excited tumbles of words and a wry, high croon for the chorus. After waiting "some time to prove that I can trust you again," she promises, "I'm gonna kiss up and rub up and feel up / Kiss up and rub up and feel up on you." It might seem like an ordinary description of making up after a fight. But notably, this is physical affection that *results* from a relationship working correctly, rather than physical affection that tries to *make* that relationship work correctly. It is sex as a sign of love and mutual respect, not an enforcer of those things.

ANY DEVOTEE OF BEYONCÉ would tell you, though, that she has long sung about romantic give-and-take. The erotic fantasy of "Partition" did, after all, bleed into a song about jealousy that might have been the germ for *Lemonade*. But pop music is not a documentary art form. It almost inevitably distorts its subjects, playing up extremes, underlining all the parts of an artist's message that suggest an ability

to transcend reality. Past works by Beyoncé capitalized on this fact, reliably making listeners feel like superheroes for a few minutes at a time.

Lemonade does not reject that mentality, but it does work on a subtler level, actively avoiding giving the impression of invulnerability. It is a vision of a life lived once the limits of #Flawless have been located, and of a society built not on individual fabulousness but by relationships where trust has been secured through negotiation. There are still extremes here in the songs that vent anger, hurt, and eventual relief; the music is creative, assured, and frequently catchy. But when it comes to making people dance, which is to say when it comes to making people think of sex, which is to say the most immediate and potent kind of pop appeal there is, she holds back.

The irony is that in withholding, Beyoncé pays tribute to the sacredness of sex. The suspicion of infidelity is what sets off the pain she must work through on the album because, in the context of her current life, sleeping with someone is no small thing. "God was in the room when the man said to the woman, 'I love you so much. Wrap your legs around me and pull me in, pull me in, pull me in,'" Beyoncé says during one of the video album's spoken-word segments. The religious comparison confirms sex's power—but suggests it's a power that can serve something greater than any one person.

A

ARCA'S UPLIFTING CHAOS

December 2021

SOMETHING ABOUT LISTENING TO ARCA, arguably the most important experimental musician working today, reminds me of sitting in a hot car to avoid getting hit by fake bullets. That memory is from adolescence, when my group of male friends would spend whole days playing at a paintball course on the military base near where we lived. I participated, but I did not love the rude *thwack* of colorful projectiles exploding on my helmet. I did not love the pathetic feeling of missing all my shots. I tended to get eliminated early from matches, head to the car, and encase myself in the headphones of my portable CD player.

Some of those solitary moments were spent listening to Aphex Twin, the influential British electronic musician I, as a budding snob, had read about on the internet. Aphex Twin's Richard D. James arranged electronic beats in complex designs that stimulated both hypnosis and hyperawareness. His music was disorienting and intriguing and generally inexplicable. Staring at James's creepy grin on the album art, I didn't know if I loved all of what I was listening to. But I did love the feeling of escaping a

suburban machismo competition for what felt like a rave in another reality.

The music of Arca, the 32-year-old Venezuelan named Alejandra Ghersi, includes a similar blend of twisted rhythms, luminous synths, and lurid vibes. Yet the deeper link to Aphex Twin is in how her music makes me, and clearly many other people, feel. Many experimental artists labor in obscurity, but some gain prominence by creating music whose enjoyment feels like deciphering the code to one's own identity.

If in the past decade you've encountered music in which earthquakes of electro noise overtake all else, it may have been Arca's doing. She produced songs on Kanye West's 2013 album, *Yeezus*, and went on to make pivotal contributions to the work of FKA Twigs and Björk. Both in collaborations and in her own material, Arca's style is not subtle. She sculpts sound so that it seems to enter the listener from their gut rather than their ears. Her melodies have the quality of summoning spells. I found her first three solo albums—2014's *Xen*, 2015's *Mutant*, and 2017's *Arca*—to be, in a word, terrifying.

Yet over the years, a funny thing has happened. Trawl around social media—especially circles where pop, queerness, or fashion is emphasized—and you'll run into Arca's name and image pretty often. You'll encounter stans whose worshipfulness is more typical of Taylor Swift listeners than the followers of radical sound designers. In a

recent TikTok with more than half a million views, someone is asked what they're listening to on their headphones. The answer is "Whip," by Arca, and as the song's violent sound effects slam in, the subject of the TikTok starts sashaying, as if to Missy Elliott. The joke captures a feeling vital to the evolution of art: pride in dissonance, pride in difference.

FOUR NEW ALBUMS OF often breathtaking music arrived this week from Arca, totaling about two and a half hours of listening time. That sheer volume feels like a provocation, on top of all the others: robot voices stammering about gore and sex, beats that thunder like garbage trucks over potholes, chords that evoke bruised fruit in their ugliness and allure. Yet these albums include some of Arca's most accessible and delectable work. Despite stretches likely to bore or bug, the best parts demand an obsessive level of replay.

The albums are sequels to Arca's 2020 release, *KiCk i*, which announced a new, poppier phase for the artist. She herself was on that album's cover (sporting claws and stilts), the guests were splashy (Björk and Rosalía howling), and the songs were catchy (but still scary). The standout track, "Mequetrefe," subjected playful keyboards to fluttering sound effects, making the listener feel as though they were watching a fancy toucan survive a windstorm. As the music video squashed and stretched Arca

without ever moving her from the center of the frame, it drove home how the key to her art is, counterintuitively, constancy. Even as every piece of an arrangement seems to mutate over the course of a few minutes, you absolutely feel that a singular personality is driving the action.

This week's four albums push that principle to a new limit as they hop between sounds and subgenres. The thump of reggaeton, the fervor of Brazilian funk, and the beauty of Venezuelan folk have long influenced Arca, but *KICK ii* is her fullest tribute to Latin music; for a few songs, she even lets her grooves unfurl smoothly, resulting in bangers that would only mildly perturb most listeners. *KicK iii*, the masterpiece of the series, uses hyperactive break-beats and rapping to create micro-moments that lodge in the brain. Then comes the slow climax of *kick iiii*—a churn of shimmery, sometimes warm atmospheres—followed by a fragile comedown on *kiCK iiiii*.

Part of what keeps this sprawling scrapbook coherent is Arca's voice, or rather her approach to voice: as a tool to be filtered into a multiplicity of characters, jabbering and hissing from all directions. Such vocal effects highlight her knack for contrast and pleasurable surprise, and she has internalized hip-hop's lesson that words can be as crucial a timekeeper as a drumbeat. When Arca swan-dives from singsong ghostliness into deeper registers on the single "Prada," it feels like the sky is conversing with the earth. On another highlight, the explosive "Ripples,"

every element of the music seems to express the squeakily sung refrain—"ripples make ripples!"—on a subatomic level.

The centrality of voice on the *Kick* albums makes a statement: Some of Arca's obvious predecessors (see Aphex Twin) kept their own identity enigmatic, and Arca herself mostly forwent singing until her third album. Yet Arca's art includes spectacles of self-revelation, including chatty Twitch streams and body-baring photo shoots. In arresting images that are part *Westworld* and part Hieronymus Bosch, the five *Kick* album covers each depict her as a cyborg deity—one plainly on a mission to inspire. "I got tears, but tears of fire," goes one *kick iiii* chorus, sung by the artist Planningtorock. "Tears of power, tears of power . . . Queer power."

QUEER POWER BOTH UNDERLIES Arca's radicalism and connects her to broader musical trends. Glitches—sounds that intentionally evoke malfunctioning machines—are everywhere these days: in the chaotic loops of TikTok, in the choppy samples of Hot 100 rap, in the aggressive bustle of hyperpop. For Arca, as she explained in a 2020 *Glamcult* interview, such glitches represent the insufficiency of language to express internal truth—a dissonance that we can all understand on some level, but that she has felt acutely as a transgender woman. "I think sometimes conversations about gender are specifically

complicated," she said, "because maybe they are, in a good way, a dead end."

Indeed, there is a way of listening to Arca's music as a tangle of metaphors about identity. Speaking to the performance artist Marina Abramović, Arca once described transitioning as revealing "static that was inside me that others didn't realize was there . . . so now it can cause friction between my environment and my identity, but it feels less noisy that way than to keep it in." As she sings about the body in terms that others might find gruesome, the shape-shifting brutality of the music illustrates the nature of uncompromising expression.

Queerness also informs her music's more inviting characteristics. With the *Kick* series, Arca has put herself more in conversation with the archetype of the pop diva—that feminine dominator of the masses who historically draws the most fervent worship from LGBTQ fans. (Deconstructing such women's power was also the project of the late artist Sophie, a trans producer who felt like the kandi-raver yang to Arca's leather-dungeon yin over the past decade.) On *Kick ii*, Arca collaborates with Sia on a track that only lightly complicates the hitmaker's grand crooning. Another diva of sorts, Shirley Manson, of the band Garbage, shows up on *kick iiii* to monologue about "the alien inside."

The notion of an "alien inside" is certainly a queer one—but it also speaks to the broader sense of social

dislocation and mysterious individuality that experimental music can stoke. My recent days of consuming the *Kick* series in headphones while jostling on subway cars and walking past sidewalk brunches gave me that teenage thrill of using music as a separator between yourself and your environment. But as I've grown closer to understanding the creator of the madness in my ears, Arca has also offered a reminder of the ways in which sounds—no matter how strange—can bind people.

LISTENING TO M.I.A.,
FINALLY

March 2018

BLACK AND WHITE POLKA DOTS covering her nine-months-pregnant belly, M.I.A. sauntered onto the Grammys stage in 2009 for a performance that would seem to announce the arrival of a supremely 21st-century sort of icon—artistically daring, proudly female, and from a part of the world the West has often ignored. But in retrospect now, the moment stands as the apex of her supposedly finished music career, a summit never reached again. Anyone unfamiliar with M.I.A. but familiar with the scripts of stardom could assume what came next: difficulty following up a barrier-busting hit, mistakes with the press, and personal setbacks.

Stephen Loveridge's documentary, *Matangi/Maya/M.I.A.*, appears to start filling in that script, preluding the Grammys performance with footage of the rapper and producer's breezy home life in Los Angeles. Then we see her arrive on stage in those blazing maternal polka dots, with the Clash-borrowed groove of her smash "Paper Planes" twitching to life, and—

Bang. The film smashcuts to news footage about the Sri Lankan Civil War, entering its bloody final phase in early 2009. The country's military had, after decades of battle, beaten back the resistance fighters of the Tamil ethnic minority to a spot on the northern coast. "No-fire zones" for civilians to take refuge in were drawn by the government—and then bombed by that government, killing hundreds on a daily basis. The screen floods with images of the wounded and dead.

This is not a normal pop documentary, because M.I.A. was not a normal pop star. Though the public came to regard her as fitting the mold of a troublesome diva, it was for an unusual reason: her insistence on delivering an unorthodox political message, no matter the forum. On Tavis Smiley's show earlier in 2009, she'd responded to a question about her artistic success by changing the subject to the "genocide" going on in her home country of Sri Lanka. On the Grammys red carpet, she sparred with a reporter over CNN omitting similar comments about genocide she made during an interview that, when it aired, focused on her music career. "You're the first person that we've interviewed that says, 'The piece was too much about me,'" the reporter shot back. "People mostly want it about them."

Loveridge's movie is a fantastic and kinetic fulfillment of Maya Arulpragasam's desire, back then, to be heard

as more than an entertainer. Starting with her 2004 debut, M.I.A. beat an aesthetically game-changing and controversy-strewn path across pop culture, broadcasting her backstory as a Tamil revolutionary's refugee daughter who was trained in London art school and steeped in US hip-hop. Her early aspiration of becoming a documentary filmmaker means Loveridge has a trove of electrifying pre- and post-fame footage to work with, which he uses for a smart, lively investigation of M.I.A.'s own vital themes: the lives of immigrants worldwide, the plight of the Sri Lankan people, and the question of whether pop stars can make effective political activists.

In 1985, the young Arulpragasam came with her mother, brother, and sister, alongside a wave of Sri Lankan refugees, to South London, leaving behind her father, Arular, whom she barely knew. That father, for whom her first album is named, has long held a contested, un-pin-downable place in her mythology. "This is what happened to a kid whose dad went off and became a terrorist," she says into the camera during a mid-'90s confessional she filmed, though later in the press she would emphasize his role as a peacebroker and humanitarian.

Remarkably, the viewer gets to meet the famous Arular, whom Maya films when he comes to visit his estranged family. He describes the conflict in Sri Lanka as a human-rights crisis, he says he was the founder of the Tamil resistance movement, and he tells a story of

smuggling bombs by hiding them under toys for his kids. Two of the three Arulpragasam siblings consider him a deadbeat. "His whole life is a dead end," Maya's brother, Sugu, says. "So now he's talking about peace. Because he can't fight now." Maya, though, has a provocatively grateful take: "He's made us damn interesting. He's given us a bloody background!"

Her quest to understand this background—and document it—would send her on a 2001 trip to her childhood home in Sri Lanka. We see her hosts then were welcoming, but reluctant to share war stories, fearful of being caught in crackdowns on dissidents. They also appeared reluctant to take her interest in the Tamil struggle seriously—because she was a young woman, and because she was an expat. In a striking moment, one of her subjects dismisses her credibility because she left the country as a child. "You never had the war zone experience," he says with a smirk and a swat at the camera. Right there is the paradox of the refugee: In Sri Lanka, she's an interloper, but in the West, she's treated like that too.

That sense of placelessness—which could be conversely channeled as *everywhereness*—fueled her vibrant, riotous sound. Bookending the movie is the video shoot for her 2015 song "Borders," whose valorization of refugees and migrants underlines M.I.A.'s significance in a post-Brexit, post-Trump world: If some politicians have their way, her story might not have been able to happen. Seen in the doc

hopping across continents to record her classic 2007 album, *Kala*, she bonds with some of her collaborators, like the Nigerian rapper Afrikan Boy, as immigrants. "There's always going to be something different about us that doesn't relate to a white experience or a Black experience," she says. "It's always something extra. Something else that you have to go and do, which is connect with your back-homeness."

It's her attempted connection to her home that generated some of the most contested moments of her career, which in turn underscore the difficulties of using the entertainment ecosystem as an advocacy platform. Her 2009 "genocide" comments were meant to bring international attention to Tamil civilian casualties. But they mostly only invited notice from government-sympathetic Sri Lankans who said she was too friendly with the Tamil Tigers, designated as terrorists at the time by many international authorities. "I tried to do it the way they wanted me to do it, which is learn a script, learn the five sentences you wanted to repeat in the news," she says. It didn't work.

But when she turned to more radical methods in her art, she met with even more blowback. At the height of her fame, she released the single "Born Free," a galloping punk-rock track with a big-budget music video in which red-headed white boys are rounded up and executed in graphic fashion. Today, it's obvious it was an allegory for real-life war crimes in Sri Lanka, but at the time, the

A

discussion that ensued was mostly around whether M.I.A. had undertaken provocation for its own sake. Such was the gist of an infamously snarky 2010 *New York Times Magazine* profile of M.I.A. by journalist Lynn Hirschberg, who's seen in the documentary raving about the "Born Free" video to its creator.

Rather than the bubbleheaded poseur that her critics made her out to be, M.I.A. comes across as sharp and articulate throughout the footage Loveridge chose, and there's zero doubt of her serious interest in her causes. But you still see how she could get in her own way. Included is old home footage of Arulpragasam fighting with her musical mentor, Justine Frischmann of Elastica, who gently, with a sense of fatigue, accuses Arulpragasam of being addicted to attention. We also get a revealing look at Madonna's 2012 Super Bowl halftime show, during which M.I.A. flipped the middle finger to America, leading to a lawsuit from the NFL. Her post-facto rationale changes a few times—was she protesting backstage sexism and racism, or was she just shoring up the image implied in the title of her then-current single, "Bad Girls"? It's not clear whether she herself knows for certain.

The irony of the Super Bowl episode, which Loveridge underlines, is that Madonna's performance ended by spelling out the words "WORLD PEACE." Peace, for the Tamils and for displaced and marginalized people worldwide, is exactly what Arulpragasam's been agitating for all

along—though with rude gestures, explosive percussion sounds, and the fictional genocide of gingers. Her post-*Kala* musical output has been patchy, but there's been enough brilliance that fans might lament how scandal has outdrawn the songs in terms of conversation (2010's *Maya* and 2013's *Matangi*: way underrated). Loveridge's documentary makes the music a somewhat secondary concern too, but it's not to fixate on the drama. It's to give M.I.A.'s deeper messages one more shot on stage, and it's, gratifyingly, a memorable one.

A

THE VINDICATION OF
JACK WHITE

June 2022

SOMETHING PREPOSTEROUS WAS HAPPENING the night I visited Third Man Records in Nashville. The label and cultural center founded by Jack White, of the White Stripes, generally strives for a freak-show vibe; you can pay 25 cents to watch animatronic monkeys play punk rock in the record store, and a taxidermied elephant adorns the nightclub. On the March night when I showed up, Bob Weir of the Grateful Dead was performing. Through a pane of blue-tinted glass at the back of the stage, another curiosity in White's menagerie could be glimpsed: a 74-year-old audio engineer in a lab coat who calls himself Dr. Groove.

In a narrow room behind the stage, Dr. Groove—his real name is George A. Ingram—stooped over a needle that was etching Weir's music into a black, lacquer-coated disc called an acetate. This is the first step in an obsolete process for producing a vinyl record. The lathe he used was the very same one that cut James Brown's early singles, in the 1950s.

Observing this process intently was White himself. Thanks to the endurance of early-2000s White Stripes hits such as "Seven Nation Army" and "Fell in Love With a Girl," the guitarist and singer is one of the few undisputed rock gods to emerge in the 21st century. On this evening, White, now 46, wore half-rim glasses and flannel, the only hint of rock coming from the Gatorade-blue tinge of his hair.

Listeners generally want a record to sound as loud as possible, White told me as Dr. Groove continued his work. But "you can have a mellow song like this"—the Dead's downbeat "New Speedway Boogie" drifted in the air—and then, all of a sudden, the drummer hits the effects pedal and pumps up his volume. If Dr. Groove isn't prepared, "the needle will literally pop out of the groove from the jolt," rendering the recording useless.

For so finicky an operation to take place in 2022 is, from one point of view, absurd. The music industry largely stopped cutting performances directly to disc 70 years ago, with the advent of magnetic tape. A few minutes before taking the stage at Third Man, Weir—a septuagenarian cowboy who spoke in a low mutter—had visited the back room and marveled that not even the Grateful Dead, those ancient gods of concert documentation, had captured a show in this fashion. "Cat Stevens said the same thing," White told me.

Ever since White installed a lathe at Third Man, a stream of acts has come to teleport to the time before Pro Tools. Unlike a recording made with contemporary equipment, a performance etched into an acetate can't be easily remixed or otherwise reengineered. Flubs, flaws, and interference instead become selling points—evidence of a recording's authenticity. "People who know, audiophiles—they see 'live to acetate,' they know the circumstances under which it was made, and it's exciting," White said. "There were no overdubs on that guitar. That solo really happened at that moment." A sticker on one acetate-derived record for sale in Third Man's store, by the dance-punk band Adult, promises "such detail in this live recording, you can even hear the fog machine!"

White is the sort of listener who appreciates such detail. This spring, a clip made the rounds online in which White demonstrated his uncanny ability to identify any song in the Beatles' catalog in one second or less. This keen sense of the past helped the White Stripes—the Detroit band he formed in 1997 with his then-wife, Meg White—revive classic-rock rawness in an era of plastic pop and space-age hip-hop. After the band's breakup, in 2011, his solo records earned consistent if narrower acclaim. Lately, though, his obsession with the antique has made him an unlikely power broker in what was supposed to be the digital age.

Streaming, the cheap and convenient format that came to rule the industry in the past decade, has begun to grate on a diverse range of artists and listeners. Musicians' foremost gripe is about money: Spotify, the dominant platform, reportedly pays a fraction of a cent whenever a song is played. When, more or less overnight, the pandemic made touring impossible, the difficulty for most acts to make a living from such an arrangement became painfully clear.

The virus also spurred a public reckoning with Spotify earlier this year. A number of artists, including Neil Young and Joni Mitchell, pulled their catalogs from the platform to protest its exclusive deal with the podcaster Joe Rogan, who had aired misleading information about COVID-19 vaccines on his show. In the eyes of those dissenters, Spotify's unwillingness to remove Rogan reinforced the idea that it views music as just another offering in a buffet of content.

The devaluing of music as an art form, many artists worry, is hardwired into the streaming format. The old ways of building relationships between act and audience (liner notes, audio quality) are subordinated by the new: algorithmic curation, which invites endless listening but not active engagement. This may seem like the way of the future, our tastes intuited and satisfied by strings of code. But while the medium continues to attract new users, some listeners are showing signs of streaming burnout.

A

One way to measure this sentiment is by looking at the popularity of the physical media that White has long championed—and that ought, in a streaming-enabled world, to have gone extinct. After languishing for years, vinyl sales began a steady climb around 2007 and then exploded during the pandemic. Last year's 41.7-million-unit, $1 billion gross for the medium represented 61 percent year-over-year growth, and this after a 28 percent spike in 2020. Limited-edition records—sold for upward of $30 a pop at retailers such as Target and Amazon—have become integral to release strategies for the likes of Taylor Swift and Adele, who last year sold 318,000 vinyl copies of her most recent album within two months of its release. The same direct-to-acetate ritual Weir and Dr. Groove performed at Third Man's shrine to music past also produced the first live album by Billie Eilish, the 20-year-old Gen Z phenomenon known to eat spiders on YouTube. Maybe White had been onto something.

WHITE'S THIRD MAN LABEL got serious about reviving vinyl in 2009. Even his friends wrote it off as a vanity project in keeping with his other willfully retro larks, such as his upholstery hobby (don't throw away the old; make it new) and his co-ownership of a company that manufactures baseball bats ("Built to spec . . . for the athlete that competes with a warrior's mentality"). He was full of grand pronouncements in defense of the old, hard ways of

doing things. "Technology is a big destroyer of emotion and truth," he declared in the 2008 documentary *It Might Get Loud*.

Today, in conversation, White has an innocent, almost surfer-dude affect, though his appetite for discussing outmoded forms of technology has hardly waned. While we were hanging out with audio engineers, he proposed a guessing game about when 8-track cartridges were last on the market. (White doesn't own a smartphone, so a member of Weir's entourage looked it up. The answer, per Wikipedia, was late 1988, vindicating White's memories of seeing such tapes as a teen at Harmony House Records in Detroit.) Later, in Third Man's lounge, he described waiting months to see Paul Thomas Anderson's *The Master* on 70 mm, only to have the experience ruined by a screaming baby in the row in front of him. The point of the story wasn't that someone had brought an infant to a psychosexual thriller about a cult leader—it was that White had really wanted to enjoy the movie on celluloid.

I'll admit that I arrived in Nashville skeptical of White's nostalgist views. Some of my most crucial music memories include pirating Green Day on Napster and spacing out to Sufjan Stevens through Bluetooth speakers. Analog obsessives, I've found, can be dismissive of the powerful relationships that streamers form all the time with new artists. And some vinyl heads treat music mainly as an acquisitive hobby, like sneaker collecting.

A

The records remain safely in their sleeves, lest their value as commodities be diminished by taking them out to play.

But White is less doctrinaire about these matters than I feared. With Third Man now a cultural fixture, he seems less like a strident iconoclast than a peacemaker between the streaming economy and the stuff economy. He insists that he never wanted to stop the march of progress; he only wanted to make sure the past didn't get torched along the way. As he put it, "It's hard to inspire only with one set of ways—only with the digital part, only with the vinyl part."

White told me he listens to 90 percent of his music digitally. He appreciates the way that streaming helps new acts find wide audiences. (Olivia Rodrigo, whose debut single made a swift transit to No. 1 thanks to Spotify, is one of the young pop artists he admires—which is cute because she herself is a White Stripes obsessive.) "I know it's not amazing money on streaming, but if vinyl hadn't blown up over the last few years, it would be a lot more dire," he said.

I gave White the chance to take a victory lap for saving vinyl from what seemed like certain doom, but he was quick to credit the figures who sustained the format in the '90s and 2000s: house DJs, punk bands, Pearl Jam. Still, he acknowledged that Third Man had played an outsize role. At first, the company focused on kooky innovations, including records that projected 3-D images when spun.

(Disney borrowed the same hologram artist for a 2016 *Star Wars* soundtrack, which shot up an image of a TIE fighter or the Millennium Falcon.) "I never minded the gimmicks," White said. "If it turns a kid on to music that they would have never gotten into, then whatever."

Today, Third Man has the makings of an old-media empire. Divisions in Nashville and Detroit master music, publish books and rock-focused magazines, and develop photography. Last year, the company opened its third record store/rock club/wonder emporium, in London. But Third Man's greatest source of influence may be the record-processing plant White opened in Detroit in 2017, which has tripled its manufacturing capacity since then. Day and night, the facility whirs along, not only pressing Third Man's work—such as the record that will result from Weir's gig—but also filling contract orders from behemoths such as Paul McCartney, BTS, and Beyoncé.

White's forays into the future haven't always been as successful as his treks to the past. In 2015, he joined a group of superstars—including Jay-Z, Beyoncé, and Madonna—with an ownership stake in the Spotify competitor Tidal. A press conference about the virtues of an artist-driven platform was met with skepticism. Tidal was, specifically and flagrantly, a *celebrity*-driven platform. The service did tout higher audio quality and better payouts to artists than competitors, but user sign-ups were slow, and the service never found its footing. White, who was not

involved with running the company, said the backlash was eye-opening. "I don't think [Tidal] was promoted properly from the get-go," he said. "It quickly became a lesson: Maybe people don't like it when the artists own the art gallery . . . It sort of gets to 'Eat the rich' kind of stuff."

White winced when I asked about an even more contentious attempt at revolution in the music world: nonfungible tokens, or NFTs. As the pandemic wore on, some record-industry figures argued that giving fans the ability to purchase digital assets—interactive album art, or even ownership rights to a song—would fulfill the same yearning for collectibility that has helped drive the vinyl boom. Others—White now among them—see NFTs as a way to get listeners to pay for things they can generally get for free. "It gives off a vibe of 'Well, if people are stupid enough to give me money for this, I'll take it.'"

But in 2021, the White Stripes—a legacy brand more than a band at this point—hawked some NFTs, animations tied to a 10-year-old EDM remix of "Seven Nation Army." White said that those had been pushed by the defunct band's management. "I don't want to come out and say 'I had nothing to do with this,'" he told me. "It is my band. We allowed it to happen. But it didn't really interest me. It's not something we'll be doing very much of."

What does interest White is the internet's broader music landscape—despite the fact that he isn't the most fluent participant in it. He appreciates how underground

scenes and subcultures, which might seem like logical casualties of streaming, haven't quite died out: "You almost get a neighborhood feel in the TikToks and—what is it?—the Bandcamps and SoundClouds," he said. (Witness the recent wave of chatty, droll post-punk bands such as Wet Leg, a favorite new find of White's.) He even had a kind word for social media platforms such as Twitter and Snapchat, not that he uses them. In their character counts and time limits, he sees proof of one of his favorite theories: Constraint is the mother of creativity. "There's inspiration to be taken from all of that stuff," he said.

WHITE HAS ALWAYS THRIVED within constraints, many of them self-imposed. The White Stripes famously had no bassist, and White originally composed his 2018 solo album, *Boarding House Reach*, with the same reel-to-reel recorder he used when he was 14 years old. For the two records he's released this year, April's *Fear of the Dawn* and July's *Entering Heaven Alive*, White didn't need to dream up new limitations. The pandemic did that for him.

When the coronavirus made studio sessions with other instrumentalists a risk, White, a consummate collaborator (besides the White Stripes, he has formed two other successful bands over his career, the Dead Weather and the Raconteurs), did something he'd rarely done: He played all the parts on his songs. This in turn required another previously unthinkable step: using software to arrange

drums, guitars, keyboards, and even samples into a coherent whole. Once, the *enfant terrible* of the White Stripes had routinely denounced computers for their deadening effects on rock. But the technology has improved since Nickelback's heyday, and White now believes that, in the right hands, it can stoke the life of a song rather than sap it. "It's like, CGI in movies is so much better than it was in the early 2000s," he said.

As social distancing loosened up and White brought in other musicians to record the songs he'd been writing, the resulting work fell into two categories: thrashing, Deep Purple–inspired rock and roll, and sweet, "Maybe I'm Amazed"–style love songs. His past solo albums had been mishmashes of styles, and he had assumed that this time he'd end up with another eclectic collection. But, he explained, instead of fitting together naturally (he knitted his fingers), the loud songs and the soft ones now seemed to repel each other (his fingers then made a crosshatch). The muse was pushing him toward two separate albums— though not a double album, which he knows screams *filler*. ("People even say that about *The White Album*, which seems shocking.")

Both the mosh-worthy *Fear of the Dawn* and the brunch-friendly *Entering Heaven Alive* are among the best albums of White's solo career. The lead single on *Fear of the Dawn*, "Taking Me Back" (which spent a few weeks at No. 1 on rock radio), has guitar jolts so menacing that

they almost trigger a fight-or-flight reflex. White likes that the title phrase can be heard a few different ways. "Maybe the pandemic has made everybody ask the world, 'Will you take me back as we emerge from our caves?'" he told me. The lyric is also a way for White, the father of two teenagers, to link his generation to the next. "When you kids do that," went White's alternative reading, "it takes me back to when I was a kid."

A RENEWED APPRECIATION FOR the tangible should be a boon for musicians who have struggled in the streaming era, a period in which rising profits for the industry as a whole have only incrementally benefited most individual artists. But demand for vinyl now exceeds manufacturing capacity by astonishing margins. A record that would once have taken three months to go from recording to the shelves today requires eight months or a year. Even White has been a victim of the lags; he'd originally considered releasing his new albums on the same day, but with his plant at capacity, he decided to stagger them. He has dubbed his present concert series the Supply Chain Issues Tour. As he tries to expand production at his Detroit factory, White finds himself more and more preoccupied by "regular manufacturing-plant kind of problems," he said. "How many shifts do we have? Once you start the machines, how many hours do you keep them going?"

But Third Man can only do so much: In 2021, an unnamed industry executive speculated to *Billboard* that global pressing capacity would need to at least double to meet present demand for vinyl. Some indie figures blame the bottleneck on the pop stars who have bought up time at small pressing facilities. The real problem, White argues, is a lack of manufacturers. He recently filmed a plea for the three major record labels—Universal, Sony, and Warner—to build their own factories. Vinyl is "no longer a fad," he said, standing amid the hazmat-yellow equipment of his pressing plant. "As the MC5 once said, you're either part of the problem or part of the solution."

In the meantime, artists are stymied by scarcity. Some commentators in the music industry see this as a sign that musicians need to focus on reforming streaming services or advocating a return to paid downloads. Others say that less unwieldy formats, such as the humble cassette tape, would be a more sustainable medium for collectors (sales of tapes have indeed begun rebounding recently). White has always wanted all of the above. When he launched Third Man's first store, he had dreams of iPads packed with MP3s next to 1940s recording booths, and of customers accessing both a record-of-the-month club and an online streaming library of live music. While not all such plans have come to fruition, when I visited the Nashville location, I was amused to find a rotating rack displaying CDs for sale, as if at a Tower Records in 2005.

Yet there is no doubt that the very things that make vinyl a chore to replicate—the bulkiness, the frameable album art, the fingerprint-like grooves that differentiate one record from the next—are part of why vinyl is surging right now. It's the sort of paradox that has animated White's entire career as a songwriter and businessman: romance leading to frustration, frustration leading to romance.

IN THE BLUE ROOM, Third Man's concert venue, Weir and his band Wolf Bros preached between songs. The bassist, Don Was, who is also the head of the legendary jazz label Blue Note Records, gave a spiel about the glory of "authentic," Auto-Tune-free music. Weir recalled his teenage vinyl experiences. "You'd go to a friend's house, and you'd put records on and you'd listen to music all night," he said. "People don't do that anymore, because you can't. You can't listen to digital music for very long, because it makes your brain tired."

The crowd whooped, but I felt a defensive pang. We all fetishize our formative listening experiences—whether they were dancing to jug bands on vinyl 'til sunup or vibing to Frank Ocean on an iPhone while riding the subway. Still, maybe Weir was right: Whose brain doesn't feel tired these days? What if I've been addicted to musical fast food since first downloading MP3s at age 11? What if entire generations have been?

A

Looking around at the audience offered a less declinist narrative. Many of Weir's followers were 20-somethings in flannel; they twirled alongside a few grizzled, Merlin-looking guys who no doubt had been attending shows like this one for decades. The legendary, highly physical sub-culture of the Dead—an ecosystem of bootleg recordings, concert tailgates, and tie-dye merch—appears to still be going strong. Indeed, it has provided a model that many of today's acts are embracing. Live ticket sales have surged in recent months. Rappers and indie singers alike are moving branded hoodies and hats faster than they can manu-facture them. Even in the slick, futuristic world of K-pop, fans express their devotion by snapping up CD bundles laden with such delights as key chains and postcards. Fans download and stream, but they still thirst for a connec-tion with artists that isn't mediated through a screen.

I circled backstage to find White hanging out with staff. As we watched Dr. Groove gingerly turn over an acetate, White described the layers of quality control in the process of making Weir's record. "You know that show *How It's Made*?" he asked. "I get so jealous: *Oh, they make razor blades, how hard!* They just build the machine and it pumps it out. But we have to make something that sounds good when you put it on your turntable. There's magic dust in there."

Weir finished up "Saint of Circumstance," the last of the songs that Dr. Groove had planned to capture. His

assistant marked the record with a pen, and then placed it into a cardboard container. "Vinyl is final!" White shouted.

Weir wasn't finished playing, though. As his encore of "China Cat Sunflower" and "I Know You Rider" stretched past the 10-minute mark, Third Man's reel-to-reel recorder—striped red and white in the White Stripes' classic aesthetic—ran out of material with which to record backup. Loose tape flapped and jangled. "This machine was not built for this type of jamming," Bill Skibbe, White's longtime audio engineer, said. Someone suggested ripping the rest of the show from YouTube, but audiences at Third Man are typically asked not to film concerts. White prefers that the only glow come from the electric candles that flicker from wall sconces, not iPhones held aloft. The encore would not be lost, however. White's team had yet another device capturing the show for posterity: a digital recorder.

A

II

THE STAGE

THE PLOT AGAINST PERSONA

September 2019

IT'S ALWAYS BEEN INTUITIVE TO think of Lana Del Rey as a "character": some fiction combining Jessica Rabbit and Joan Didion, drawn up around 2010 by the real human Lizzy Grant. And it's always been wrong, supposedly. "Never had a persona," Del Rey tweeted earlier this month. "Never needed one. Never will."

That statement came amid Del Rey's diss of an essay by the NPR music critic Ann Powers. In more than 3,500 careful words about the new album *Norman Fucking Rockwell*, Powers had saluted Del Rey's use of pastiche, cliché, and, yes, persona. She also said that some of the songwriting felt "uncooked." Del Rey didn't like that. "I don't even relate to one observation you made about the music," she tweeted at Powers. "There's nothing uncooked about me. To write about me is nothing like it is to be with me." Another tweet: "So don't call yourself a fan like you did in the article and don't count your editor one either—I may never never have made bold political or cultural statements before— because my gift is the warmth I live my life with and the self reflection I share generously."

Artists have always had reason to trash their critics, but Del Rey's attack came in a year when musicians have seemed especially defensive. Lizzo lashed out at a mixed take on her new album, Ariana Grande blasted "the blogs" as "unfulfilled" and "purposeless," and Chance the Rapper suggested that his skeptics wanted him to die. Music criticism is in a relevance crisis—publications are closing and streaming threatens to render parts of the job obsolete—so why are musicians sweating negative feedback so much? Maybe the world of social media makes artists more exposed and encourages them to hit back. And maybe the role of the persona, a crucial concept in pop history, is in flux.

Del Rey's assertion that she's never had a persona is laughable given how much flak she's gotten for seeming to live in costume. She has a stage name that she said the music industry coaxed her to adopt. She has a fashion shtick so well-defined that people can go as her for Halloween. She writes lyrics in a style that makes it seem like she wormholed from an early '70s LSD cult and then tried to learn modern slang from a Rihanna song. Her defenders have always said that it shouldn't matter that she's artificial, as all great pop musicians are. But it's clear now that that's not actually how she wants to be defended: She rejects the premise of the entire conversation.

IN 2013, AN OLD SONG BY Lana Del Rey leaked, and it was a doozie: a diss track against Lady Gaga. Before either woman had become famous, both had played in New York City nightlife circuits. It appeared they were friends, but the Del Rey song, "So Legit," seemed to blast Gaga as talentless and fake. "You're looking like a man, you're talking like a baby," Del Rey sang, airing some very-common-in-2009 idiocies directed at Gaga. "How the fuck is your song in a Coke commercial? Crazy."

The notion of a divide between Del Rey and Gaga—both of whom have grappled with charges of inauthenticity over the years—is instructive. Back at the start of her career, Gaga entranced the press as a shape-shifting cartoon creature who gave sassy-cryptic interviews. There was no doubting that the "fame monster" Gaga was an entertaining fabulation, even though she'd go around saying things like, "The largest misconception is that Lady Gaga is a persona or a character. I'm not—even my mother calls me Gaga. I am 150,000 percent Lady Gaga every day." Such statements could be brushed off as method acting. After all, her obvious predecessors—Madonna, Prince—often didn't break character in their early days. David Bowie held funerals for his personas once he was ready to move on from them.

Move on, Gaga did. After pushing her couture and her sonic bombast ever more outlandishly through 2013's

Artpop, she began an act of striptease, with pared-back albums and a documentary that purported to show the "real" her. She talks now about Gaga as, yes, a persona, something outside of herself. "It is a bit of a creation," she said in 2016. "But it's other people that have created [it] through what I've made; their perception of what Gaga is, is a separate entity from me." But the persona isn't gone: See all of her high-concept runway moments promoting *A Star Is Born* (the showtunes-singing Italian American family girl we see in latter-day Gaga projects is a performance, too). In taking on that movie role, Gaga underlined the idea that she, like her character, Ally, built up a persona that she could then remove at will.

Del Rey arrived at fame in 2012, and she seemed both out of time and perfectly timed. Just as Instagram's nostalgic filters and the bricolage identity-curation platforms like Pinterest were catching on, here was someone gluing together disparate references using a Super 8 aesthetic. Her music combined Golden Hollywood strings with hip-hop skittering, which fit the lyrics of someone who called herself "gangster Nancy Sinatra." If this was "pop," it was also weird. The music unfolded too slowly to fit with the *untz-untz* trends that Gaga led. Del Rey was out of step in a deeper way, too: her politics.

Del Rey's shtick was insistently feminine—"This Is What Makes Us Girls," went the title of *Born to Die*'s glorious closing track—but it wasn't *feminist* in an obvious

A

way. In her breakout single, "Video Games," she doted on a remote, neglectful man. Most of her debut's songs did something similar to this while also contemplating death and suffering as something glamorous. This was unusual in the 2012 moment, when explicit embraces of "empowerment" had become key to pop performance. Sympathetic reviewers over the years found ways to read Del Rey as subversive: She satirized that which she sang about, and she made space for female sadness, and she embraced the freedom to be whoever she wanted. All such readings required leaning heavily on the notion of persona. Del Rey *had* to be singing one thing when she really meant another.

She didn't say that was so, though. In 2015, she said, "I definitely don't need a persona to create music, it's not a David Bowie type of thing necessarily." In another interview she brushed off the idea that she was working in the realm of exaggeration, instead hinting at biography: "You know, there's a lot of stuff I could've not said in the songs and I said it anyway. It didn't always serve me to talk about some of the men I was with and what that was like, and then not comment on it further." One track that surely seemed like parody, 2014's "Fucked My Way Up to the Top," she clarified, was truth telling about a relationship she had with a label executive.

Maybe Del Rey's just trolling. But at a certain point it becomes weird to not take her own words at face value.

Over the years, she's basically kept singing about the same things, with ever so slight shifts. On the title track of her new album, *Norman Fucking Rockwell*, she mocks the overconfident male type who she would have once swooned for—but she does, however, still swoon. Though her four albums since *Born to Die* have been very good, they've not been very evolutionary. One album will lean more pop and one will lean more opera. There's more space, and nuance, and harmonic yumminess on *Norman Fucking Rockwell* than ever before. Mostly, though, there's Lana Del Rey being Lana Del Rey. Which is who?

ANN POWERS'S ESSAY IMAGINED THAT Del Rey is exactly who she's said she's been. It started by taking something the musician said in an interview, about spending most of her time at the beach, not as some fabulous exaggeration from a pop trickster but as an actual biographical tidbit—and then speculated on which beach might suit her. It went on to evaluate Del Rey on the terms she's always asked to be evaluated on: as a "singer-songwriter" in the lineage of "Joni Mitchell or Tori Amos" with "piano, lyric poetry, a voice cultivated by singing hymns and lullabies" to achieve "legible expressiveness." Throughout *Norman Fucking Rockwell*, Powers wrote, Del Rey presents herself as "a woman sitting at a keyboard, singing what she needs to say."

Powers went on to say, however, that Del Rey's singer-songwriterliness wasn't what made her "an interesting

artist." Instead it was "her compulsion to collapse logic, to violate boundaries musically, through imagery and within her storytelling." This is correct. It's Del Rey's meta-meanings, the way she signals and evokes and alludes, that make her obsession-worthy—not what's in the words but what's in between them, and around them. When Del Rey picks Sublime's "Doin' Time" up from the used-CD bin and delivers a deadpan femme-fatale version, she is conveying not just a melody but also something more ambiguous about gender and place and genre and love. "For Del Rey, the mash-up of affects and references is the point," Powers wrote. "It is emotion's actuality."

Emotion's actuality should be the songwriter's dream, and Powers said Del Rey achieved it. So why the singer objected isn't quite clear—though her clapback gives the impression that she thinks Powers overcomplicated things. "My gift is the warmth I live my life with and the self reflection I share generously," she tweeted, which is a funny statement on multiple levels. The Del Rey who comes across in song is many things, but "warm" is not among them. She certainly doesn't seem to be simply *sharing* her feelings, like a diarist. She is mediating them. She is slotting them in a cultural context. They're all the more powerful for that. It's tempting to wonder if Del Rey bristled *because* Powers got it right: She noticed how the magic trick works.

Or the disagreement could really be about persona. Powers wrote of Lizzy Grant creating a "character" out of

her subconscious (and America's), but what if it's not a character? What if it's literally her? In Del Rey's Twitter bio, there is a quote: "Do I contradict myself? Very well then, I contradict myself; I am large - I contain multitudes." That's a Walt Whitman line that has become such a platitude—who earnestly quotes Whitman in 2019 other than TV parodies of pretentious literary men?—that a clever critic/listener/fan might assume it to be an in-joke. But maybe the hackneyed nature of Del Rey's reference points—as Powers wrote, "no shout-out to Sylvia Plath can feel new, not since about 1981"—is not knowing after all. Maybe Del Rey has no interest in cliché as cliché. Maybe she wants to remove the meta-meaning and get back to the meaning. She just wants to say that she contains multitudes.

Discussions of "persona" in 2019 can't help but entail citations of another dead male intellectual who's been over-quoted of late, Carl Jung. In Jung's schemas, the perfection of the self requires bringing one's persona—their "mask"—into accord with their ego and shadow. Identity crisis is ongoing, productive, and all-encompassing. In Del Rey's music, however, there are no identity crises. She is not torn between being who someone else wants her to be and being who she is. Who she is is someone who wants to be what someone else—some man, usually, historically—wants her to be. In an era of people willfully working out their identity in public, this steady blankness

A

has made her one of the most striking and strangest figures around. We have no choice but to wonder if she's kidding. That's her intrigue.

Other players in pop music have, in disparate but related ways, moved to sideline persona as a helpful schematic: Fans are forbidden to separate the art and the artist. Take Billie Eilish, one of the most fully realized, outlandish, superstar-level characters to arrive on the scene since Gaga. Blocky-graphic clothes and dead-eyed ghoul grins and music videos laden with spiders and goop—she's a performance artist, most obviously. But she's also a performer of great intimacy. On social media, her aesthetic is shaky verité. She insists that her goth-pop, hodgepodge songs connect to her actual experiences of nightmares and mental illness and ambition and heartbreak. You follow her and you do not get the sense of someone playing a role. You do not get curious about who she really is. You are instead mesmerized by her appearance of internal and exterior unity.

Go down the list of today's trending pop stars and you see similar stories of persona and person expertly made indistinguishable so as to inspire obsession among followers online. Ariana Grande once had the feel of being the Nickelodeon character she played and just transferring over to the music world; now, she mines the actual (or reported) drama of her grown-up life for quirky sing-alongs that tie in with whatever story she's telling on

Instagram. Cardi B's music is absolutely an extension of the too-fabulous-to-believe human audiences have been shown on reality TV. Few mind the didacticism of the messages Lizzo slings in song because they are so deeply, ebulliently rooted in the life that we see her living in the public eye. These stars put on highly constructed spectacles for a living. They also insist on being seen as that thing once considered anathema to such spectacles: authentic.

It's always been the case that personas are something for critics to investigate and for stars to deny the existence of. But such denials have never been as imperative for success as they are now. If Del Rey's music has all along represented some credible version of her own reality, it's all the more dazzling. Just imagine if this glamour, the pathos, the tragedy were actually real? And if it is fantasy, as so many have suspected, it is a fantasy of cohesion: life lived according to the tropes of art. Either way, it is not in her interest to encourage deconstruction. Firing off a logically preposterous, ethically dubious, but alluringly vicious barb at someone who earnestly attempts to do so is very much the kind of thing a Lana Del Rey would do.

A

WHAT IS HYPERPOP?

March 2021

IN MUSIC AND ON ROLLER COASTERS, speediness makes for the fun kind of scariness. When young punk rockers raised on the Ramones began to play their own music in the early 1980s, the rat-a-tat rumble of "Blitzkrieg Bop" accelerated into something called the blast beat: an all-out rhythmic carpet-bombing over which vocalists would groan about Satan, Ronald Reagan, and the resemblance between the two. This development pushed rock and roll's intrinsic logic—through dissonance, truth; in disaffection, pride—and invigorated new genres such as hardcore, grindcore, and death metal. In a 2016 book, the critic Ben Ratliff argued that blast beats also reflected a new technological landscape: "They were like the sound of a defective or damaged compact disc in one of the early players, a bodiless slice of digital information on jammed repeat."

Today, no drum kit is required for musicians to glitch and twitch with terrifying intensity. Open up any audio-editing software, pull a few sliders in one direction, put the resulting ugliness on loop, and there you have it: a headbangable hell-scream into eternity. Such sounds are everywhere online these days. On TikTok, I recently came

across a series of videos in which teens compared how their parents wanted them to dress with how they actually wanted to dress. As preppy sweaters gave way to nose rings and black fishnets, the music flipped from a saccharine sing-along to a harsh digital pounding. The latter sound was like a car alarm outfitted with a subwoofer—but for some reason, it beckoned to be played louder, rather than to be shut off.

These TikToks deployed a remix of music by Dylan Brady and Laura Les of the band 100 Gecs, which has helped pioneer this era's emerging misfit aesthetic. On the surface, the duo's 2019 debut album, *1000 Gecs*, is a prankish, postmodern collage of Skrillex, Mariah Carey, Blink-182, Nelly, Linkin Park, Kenny Loggins, euro-dance, and ska. What glues together such clashing influences isn't just a sense of musicality—though Brady and Les are excellent songwriters—but a fascination with amusicality. The vocals are manipulated to achieve the whininess of SpongeBob SquarePants. The grooves fracture and reroute habitually. The harmonic textures evoke train cars on rusted tracks. Confrontational and bizarre, this sound brings in almost 2 million listeners a month on Spotify.

Though 100 Gecs' music rejects classification and formulas, a fungal burst of artists with like-minded approaches has erupted in the past few years, and Spotify has started using a new genre label: *hyperpop*. Signature songs include

XIX's "Kismet," which places screams and rapping amid casino-floor bleeping, and Slayyyter's "BFF," which sounds like Kesha performing inside an air duct. As with any new taxonomy, the definition of hyperpop is blurry and contested; one meme cheekily suggests more precise terms such as *glitchcore, ketapop* (for the disorienting raver drug ketamine), and trans ragewave (because many of the creators are pissed and aren't cis). The word *hyperpop* does nail the way that the music swirls together and speeds up Top 40 tricks of present and past: a Janet Jackson drum slam here, a Depeche Mode synth squeal there, the overblown pep of novelty jingles throughout. But the term doesn't quite convey the genre's zest for punk's brattiness, hip-hop's boastfulness, and metal's noise.

As hyperpop has become a trending topic to argue over, people have at least agreed that the sound reflects its era. Here is music suited to TikTok's DIY hijinks, Twitch's video-game violence, and the all-you-can-listen-to, boundary-free possibilities of music streaming. You couldn't invent a more zeitgeist-baiting brew. But whenever a new chaotic youth aesthetic has arisen in musical history, it's been a reaction *against*, not just a reaction *to*, its times. Hardcore's blast beats, gangsta rap's provocations, and grunge's moans all used extremity to question mainstream values such as respectability, conformity, and consumerism. The irony is that the rebellion now marches under the seemingly tame mantle of *pop*.

ISN'T POP HYPER ALREADY? Trends come and go, but across the decades pop has remained broad and brash, prizing emotional exaggeration, relentless energy, and ridiculous, self-parodying personas. The rise of electronic production—which allows creators to bend the human voice and make utterly unnatural sounds—has only given pop a more deranged, artificial feel in the 21st century. Even as brooding hip-hop music began regularly outperforming peppy sing-alongs on the *Billboard Hot 100* in the past decade, certain values have stuck around. Cardi B and Megan Thee Stallion's "WAP," for example, ruled the charts last year precisely because of the hyperbolic scale of its boasts and bass.

But in the public consciousness, the term *pop* has long connoted market-driven insipidness, which has left space for styles such as rock and rap to sell themselves as inherently *alternative*. While pop is compromising, false, and cheerful, the theory goes, alternative artists are complex, authentic, and emotionally dynamic. Of course, anti-pop values have often had mass appeal—especially after the early '90s. That's when grunge went big and then fractured into a thousand Coachella acts, and when Nielsen SoundScan came along to reveal the popularity of hip-hop. The actual listening experience for many people, however, never fully lined up with insider-versus-outsider dichotomies marketed by the music industry. For a certain kind

A

of person—say, a queer kid in the early 2000s who spent time on Britney Spears message boards while being bullied by guys who listened to Staind—enjoying pop could be a transgressive move.

The story of 2010s music is in part the story of such transgressions coming to light. When Spotify arrived in the US in 2011, the buoyant sounds of Lady Gaga, Nicki Minaj, and Carly Rae Jepsen reigned. Soon, the new playlist culture—catering to café backgrounds and the intimacy of headphones—began rewarding the chill dance vibes of the Chainsmokers and the hypnotic raps of Drake. This led to two oddball online movements that fed into hyperpop. One was the "SoundCloud rap" scene of teens mixing hip-hop with nu metal and emo, those oft-mocked remnants of the alt-rock boom. The other movement saw Jepsen-style bubblegum become hipster fare. By the mid-2010s, *Pitchfork* had endorsed the satirical pseudo-superstars of the UK electronic label PC Music, which peddled deadpan hooks, frantic beats, and knowingly vapid lyrics. Addictive dance tracks by one critical darling, Sophie, used pneumatic whooshes and crinkling sounds to portray pop as a physical product: "Shake shake shake it up and make it fizz," went one robotically sung refrain.

That meta-pop wave almost seemed to mock human emotional expression altogether. But its main aim was to decouple pop's head-rush aesthetics from any commercial

expectations, thereby opening space for wilder fun. Hyperpop often uses that space—and the fusions of SoundCloud rap—to supercharge alienation. As a teen, Laura Les aspired to write hits for the boy band One Direction, even as she burrowed into obscure punk, hip-hop, and dance scenes online. When she first encountered the work of PC Music, her "depression lapsed for a minute," and it felt like "rays of god beams [were] shining down from the clouds," she recently told *Pitchfork*. For 100 Gecs' breakout hit, "Money Machine," she recorded a hilarious burst of trash talk after a day of working at a dead-end service job and finding herself in fights with men. "I had been watching a lot of *King of the Hill*, and I constructed in my head a sort of Hank Hill asshole character to just absolutely break down," she told the podcast *Song Exploder*. "I was just kind of getting into that sort of mindset of these people that I'd grown up with, these people in St. Louis talking about their big trucks."

The straight white normie: That's a hyperpop bogeyman as potent as the yuppie was for hardcore punk, or as the senator's son was for the Woodstock crowd. A notable number of hyperpop artists, including Les, are transgender. Many others are gender-fluid or gay. Plenty embrace the notion that their music's mix of sparkle, aggression, and confoundingly distorted vocals reflects a queer sensibility. Hyperpop lyrics often celebrate the divas and socialites of Y2K pop culture that the media mocked but

A

a generation of girls and gays became fascinated by (take Ayesha Erotica's "Literal Legend": "I can give you Paris Hilton, I can give you Janet / I could give you Björk, but I don't think you'd understand it"). Last year, the gender-fluid Texas singer Dorian Electra put out a concept album in which they, taking inspiration from drag, snarkily inhabited the viewpoint of incels and alt-right trolls. Between patches of fratty-sounding rapping, "Mos Thoser," by the band Food House, salutes God as trans and calls upon the listener to "make some new behaviors that straight people will infringe on." That song's top YouTube comment as of this writing: "I swear this song literally just cured my gender dysphoria."

Of course, for the growing audience that this music attracts, the disaffection embedded within it can speak to all sorts of grievances. Hyperpop thrives on so-called alt TikTok, the social media sphere fueled by goth types turned off by the coiffed choreography of straight TikTok; scrolling through alt TikTok is a lot like hanging out in the corners of a high-school cafeteria where the burners and art kids congregate. Many hyperpop songs come off like tech-addled teen comedies: "We broke up on PictoChat, crying on my DS," goes the chorus of Cmten and Glitch Gum's "Never Met!" (Yes, those terms sent me Googling.) Other tracks double down on the bristling introspection and score-settling of emo rap. The buzzy 15-year-old Osquinn makes highly melodic diary entries

asking questions like, "Why am I so ignorant? Why am I so toxic?" Rico Nasty, a rapper who often works with 100 Gecs, specializes in motivational rudeness: "If you wanna rage / Let it out / Bitches throwin' shade / Punch 'em in they mouth!"

Hyperpop is young and flickering; any day now, it might morph, die out, or go supernova. If it has a celebrity figurehead, she is the UK singer Charli XCX, who sang on or co-wrote a number of *Hot 100* smashes in the mid-2010s. Her own solo work—some of which was made in collaboration with the PC Music crowd and 100 Gecs' Dylan Brady—has gotten gnarlier and more cybernetic over the past few years as she has preached about ignoring genre categories altogether. While mass audiences haven't been thrilled by such explorations, her obsessive fan base has been. Early in last year's coronavirus lockdown, she wrote parts of her thrashing but vulnerable new album, *How I'm Feeling Now*, while letting her followers watch—and give input—via Zoom and Instagram Live. It was a fitting stunt for a sound born of the internet's ability to connect socially stranded people. "I'm online and I'm feeling so glamorous," Charli sings on one song. "In real life, could the club even handle us?" The shock-wave noises engulfing her mechanized voice imply an answer: At most clubs, this music wouldn't belong. That's the point.

A

HOW DONALD TRUMP
HIJACKED CAMP

October 2020

IF DONALD TRUMP LOSES THIS ELECTION, maybe he'll join The Village People. The 1970s band famous for leather chaps and questionable headdresses has become a wacky touchstone of this dour campaign season, and it's thanks to the president. At his rallies, crowds have been warming up to "Macho Man," The Village People's 1976 single about having pride in a "big, thick mustache." Trump himself, at the end of his speeches, has been dancing to "YMCA" with hand gestures that make it look like he's mushing in an underwater Iditarod. The emergence of Disco Donald has led to a pro-Trump "MAGA" song, a Trump-mocking TikTok meme, and a clip of Anderson Cooper trying not to cackle as a crowd of Republicans grooves to music that grew out of San Francisco bathhouses and New York drag clubs.

As if it needs to be said: The Village People are, canonically, very queer. Around 1977, the openly gay producers Jacques Morali and Henri Belolo canvassed bars for singer-actors and placed ads that read, "Macho Types Wanted: Must Dance and Have a Moustache." The crew

they hired costumed themselves as sexualized, masculine archetypes: the sailor, the fireman, the biker, the Native American chief, the construction worker, the cop. They sang songs that celebrated the guy-on-guy camaraderie of gyms, military regiments, and Fire Island. The band's pert rhythms and hammy slogans soon boomed in sports arenas and grocery-store aisles—but only after they first found an audience in gay venues.

The Trump administration has banned transgender people from the military, opposed attempts to stop sexuality-based employment discrimination, and denied visas to same-sex partners of diplomats. So it is haunting to see this particular president pick this particular band, and all it stands for, to amp his crowds. But there's something oddly predictable about it, too. That's not only because the Trump campaign has made awkward overtures to the queer community (Tiffany Trump's flailing Pride speech, to give one example). It's not only because Trump made similar use of Queen's music in 2016. (Back then, a music-history professor told me that winkingly gay jock jams excel at summoning the "carnivalesque.") It's also because the Trump era has helped re-scramble American culture's relationship to the aesthetic tradition known as "camp."

The sight of Trump shoulder-swiveling to "YMCA" while entombed in his typical boxy suit sent me searching for Susan Sontag's definitive 1964 treatise, "Notes on

A

'Camp.'" The essay—really a bulleted list—tried to describe a "sensibility" that Sontag said united the writer Oscar Wilde, the ballet *Swan Lake*, and all "stag movies seen without lust." Camp is very hard to nail down—it's a *know it when you see it* sort of thing that's more related to the viewer's reaction than to any object's intrinsic nature. But, Sontag ventured, camp's attributes include the "spirit of extravagance," "glorification of 'character,'" and "sensibility of failed seriousness." It leads people to say, "It's good because it's awful," though not *all* good because-they're-awful things count. Crucially, if someone sets out to trigger a camp response, Sontag said, they were not actually camp. They were merely *camping*. "The pure examples of Camp are unintentional," Sontag wrote. "They are dead serious." This distinction means that many things thought of as camp are really pretending to be camp—giving rise to a cheeky, mischievous aesthetic that is everywhere today.

Camp has often been associated with queerness, and Sontag made the case that this was because gay people sought to ingratiate themselves with a society that saw them as dangerous. ("Camp is a solvent of morality. It neutralizes moral indignation, sponsors playfulness.") Reflecting on the way the über-campsters of The Village People have roused NFL fans and prom-goers over the years, you can see what she meant. But Sontag didn't discuss the fact that campiness can be usefully ambiguous to

people trying to disguise their true feelings and nature, as queer folks often have needed to do. Superficial spectacles that trigger the question "Is this serious?" can entertain broadly but signify different things to different viewers. And by lavishing attention on puzzling and preposterous objects, a community can develop a set of references that amount to in-group code.

Ever since (and even before) he introduced his presidential campaign with a gilded escalator ride in 2015, Trump has been widely acknowledged as camp. It's obvious that he's ridiculous; it's not always obvious whether he knows he's ridiculous. Swaths of the electorate look at him and see failed seriousness, pointless extravagance, and an elevation of style over substance—and can't help but laugh. This includes not only his detractors but also many of his extremely online supporters, who lovingly aestheticize his hair and meme him as an action hero. By this point, Trump—or at least his advisers—know to play this up, and in doing so have turned camp into a trolling tool. Dancing to The Village People works as a pep-rally maneuver, hyping the faithful. It also works at generating fascination, distraction, and maybe even some fleeting affection from a broader audience.

Camp suits Trump's larger rhetorical style, which uses jokes and doublespeak to advance an agenda that many Americans find objectionable when stated in plain language. Does he condemn white supremacy, or does he

want racist militias to "stand by"? Does he really want to lock up Joe Biden, or is he just idly musing about doing so from the stump? Insist on clear answers to these questions, and his defenders might call you a scold. "The conservative brand of ambiguous irony looks to create asymmetries in how insiders and outsiders interpret what is being said, so that any statement that gets too much blowback can become someone else's failure to take a joke," wrote Dan Brooks in a recent *New York Times Magazine* piece, which further argued:

> This miasma of ill-defined but ever-present irony makes Trump virtually impossible to mock, because that job is taken. The real Donald Trump acts as if he's doing an impression of some normal-looking, occasionally self-aggrandizing president we don't know about. His supporters know this impression is fake. They don't think Trump is the guy he pretends to be; they know he is the guy who pretends to be that guy, which is a hilarious thing for the president to do. Trump has effectively neutralized political comedy by shifting the place where jokes happen from the soundstage to the White House. The unsettling thing about this approach is that it works—not just as a way to defang satirists but also as a way to wield power.

Brooks also notes how Trumpland's aesthetic arose at a time when the cultural left acts more earnest than ever. His examples include TV series like *The Daily Show*, on which sarcasm, silliness, and nuance have been supplanted by righteous, overt skewering of the administration. Similar realignments have happened in other arenas too. Camp does still thrive across modern society—including in memes, rap songs, everything Ina Garten does. Yet it's glaring that as the right-wing gorges on camp and campiness, much of the queer-friendly popular culture of the late 2010s has taken a more sober approach. Even The Village People themselves seem to have taken note.

WEARING HIS SIGNATURE cop helmet and white cravat in a recent video, Victor Willis, the last living founder of The Village People, explains that he asked the president's campaign not to use his music. But Trump did so anyway, and Willis hasn't taken any legal action, because it would be expensive and he's likely to lose in court.

The video, however, is more devoted to clearing up misconceptions about his band's music. "Macho Man" and "YMCA," Willis says, aren't about gay life, despite what many people think. Willis is straight, and he simply wrote these two songs as an expression of his own "street attitude" and his affection for the community center that took in young Black men like him. This assertion doesn't fully square with the opinions of other Village People

members. But by implying a mismatch between the creators' intention and the public's perception, it definitely heightens the camp appeal of The Village People. It also fits the way that a lot of entertainment once widely considered winking and frivolous has—whether explicitly responding to Trump or not—lately tried to project a deeper sense of purpose.

You can find a telling example of this shift if you go to the Spotify page for The Village People. The newest release you see there is by a buzzy 28-year-old gender-fluid musician named Dorian Electra. Electra recruited The Village People to sing on the title track for their second album, *My Agenda*, which came out this month. The song does not sound at all like "YMCA." It pairs grunting guitars and hip-hop drums like Limp Bizkit did. Electra sings in a digitally manipulated warble with slight Vincent Price affectations. The concept of the song is that it airs the fever dream of a homophobe who fears the so-called gay agenda. "My agenda might offend ya / Out here flexing in my rainbow suspenders," goes part of the chorus, which The Village People sing. At one point, Electra malevolently repeats Alex Jones's conspiracy theory that government chemicals are turning frogs "into *homo-sex-oo-alls*."

By enlisting The Village People for this one song, Electra highlights some commonalities between eras of queer pop. Electra's new album is about macho, macho men—but it's the macho, macho men of the politically

regressive internet: alt-right video gamers spamming chat rooms with Pepe the Frog memes, incels in fedoras fantasizing about perfectly docile girlfriends. Like The Village People did, Electra lavishes attention on the aesthetic excesses and self-seriousness of expressions of masculinity in their era. But the difference—or one difference—is that Electra's music is brutal satire. Sontag wrote of the camp eye as pleasure-minded and "disengaged, depoliticized—or at least apolitical." Electra is disgusted, knowing, and super engaged. They are an outright protest artist with a message to deliver.

In this way, Electra is right on trend. In the 2010s, popular queer culture spent a lot of energy rendering as text what once had been subtext. The juggernaut phenomenon of *RuPaul's Drag Race* has thoroughly demystified the art of drag, turning a set of inside jokes and inscrutable surfaces into fodder for broad morality plays. Contestants are encouraged to use costumes to express their authentic selves; the viewer is lectured about the problems of heteronormativity. Similarly, the ballroom vogue scene—in which queer people of color study the straight world's affectations to create brilliant, deadpan dances—has had all of its implications dissected and narrativized in TV shows and documentaries. There's camp in FX's *Pose*, for instance, but the aesthetic mostly serves as set decoration for televised fables about identity and oppression.

A

Pose is the work of Ryan Murphy, the famous *Glee* creator who, with a reportedly $300 million development deal with Netflix, now seems to churn out a new TV series or movie at a monthly pace. Though the subject matter of *American Horror Story*, *American Crime Story*, *Feud*, *Hollywood*, *Ratched*, *The Boys in the Band*, and other Murphy works varies widely, each one mashes up old camp touchstones for didactic ends. Sometimes the results are so ponderous that one might argue they amount to their own camp. But the primary pleasure of his shows isn't that you laugh at them, and Murphy himself rejects the term *camp* and prefers the term *baroque*: an apt label for the way he gilds piety with melodrama, comedy, and spectacle.

Each of the examples I've listed includes moments of deliciously campy entertainment; each of them builds productively on the struggles of queer people in past decades to simply exist in public without apology; each of them often succeeds as social commentary. The fact that "camp" was the theme for the 2019 Met Gala speaks to the extent to which once-snobbish disdain for excess and play has all but vanished. But if camp's mission was to "dethrone the serious," as Sontag wrote, the opposite is happening with much of popular culture. Meanwhile, the occupant of the Oval Office routinely trivializes the consequential—and amid the dire conditions of 2020, it's clear why.

TRUMP HAS BEEN CAMPY FOR the entirety of his public life, but his reelection campaign feels like an aesthetic culmination. He is an incumbent posing as an insurgent, and with coronavirus deaths continuing to mount and his poll numbers looking grim, his sense of embattlement is palpable. One result of that comes in the form of bitter confrontations with the press and dark warnings about the election's integrity. But his embattlement also colors the regular work of electioneering, which always involves upbeat rallies and hopeful promises. It is here that Trump's campaign takes on the delusional cheer of a drag queen. See: the "YMCA" dances, the parades of boats festooned like Pride floats, the strangely punctuated promises to colonize the moon, the comedy roasts of face-mask wearers, and the boudoir-style video of Trump returning from Walter Reed National Military Medical Center after being treated for COVID-19.

The Biden-Harris campaign, by contrast, has scrubbed itself of all but the mildest silliness: Biden's exasperated mantra, "Malarkey"; Kamala Harris's displays of joy; Cher's surprisingly sweet update of Judy Garland's "Happiness Is a Thing Called Joe." The campaign's ad aesthetic is folksy, stoic, and vanilla-scented; the 2020 Democrats' slogan might as well be "Keep calm and vote." Just listen to the official Biden-Harris song, "The Change," which the pop singer JoJo and the writer Diane Warren created for the

campaign. Over echoey, building piano, JoJo simply vows repeatedly to do *something* and be "the light." The song is solemn, but its music and sentiment aren't even intense enough to inspire obsession or revulsion. The feral commitment of a Trump rally—or the messianic bombast of the Barack Obama and Hillary Clinton campaigns—has clearly been judged too risky.

The Biden sensibility, wanly sincere and hard to mock, speaks to how difficult it is to communicate honestly and broadly right now. When a plague is raging, democracy is under threat, and disinformation chokes out truth, one way to react is with misdirection, jokes, and hollow hauteur: the Trump path. Another might be in the high-handed satires and sermons of a Ryan Murphy product. Yet another is the careful triangulation of Biden's crew. What would happen if someone engaged our era's challenges without the armor of humor, indignation, or circumspection? Again, The Village People offer an example.

In March, the band released a new music video entitled "If You Believe." It was meant to comfort a world panicked by the pandemic. The visuals were a pastiche of home-computer word art ("event canceled" says one slide), stock videos (doctors smiling, businesspeople fist-pumping), and archival news footage (Martin Luther King Jr. giving a speech, an astronaut walking on the moon, and, for some reason, the Twin Towers burning). As I watched, I put my hands over my mouth and tried to

stifle every honest reaction I felt. It seemed heartless to think of this deeply felt attempt at processing catastrophe as camp. But then I remembered: "Camp," Sontag wrote, "is a tender feeling." That remains true even if, lately, it has been hijacked for callous ends.

A

TIKTOK KILLED THE
VIDEO STAR

June 2022

THE DEFINING MUSIC VIDEO OF the past decade is probably the one in which Beyoncé showed off her laundry pile and Lubriderm. In 2014, about a year after the pop queen popularized the term *visual album* by surprise-releasing 17 expensive-looking music videos all at once, she dropped a lighthearted B side: "7/11." It came with a clip of the singer shimmying in drab hotel corridors, on a rumpled bed, and between bathroom counters cluttered with products you might find at CVS. Every shot could've been captured by Beyoncé herself, using an iPhone. Giggles and apparent mistakes were plentiful. The goddess of #flawless was loosening up.

Or at least, that's how it appeared. Packed with details and quick cuts, "7/11" had no doubt been sweated over like any other Beyoncé product, to clever effect. The video let viewers indulge deep-seated human desires to pry into other people's bedrooms and to connect with celebrities as if they were siblings. It also gave the public yet another chance to marvel at this particular celebrity's fabulousness: her vision, her body, her work ethic. Everyone knows

they can't be Beyoncé—but when watching this easy-breezy video, they might forget that.

Today, the most important pieces of visual media in music resemble "7/11." On TikTok, new songs surge or flop based on how effectively they entice users to perform some slapdash feat: a simple dance, a costume change sourced from the bedroom closet, a cute or cringe confession. With a booming, young user base, TikTok has become a music-promotion ecosystem of extreme importance. That ecosystem thrives on calculated messiness—producing the feeling, if not the fact, of seeing people how they really are.

One might guess that pop stars would be relieved by TikTok's ostensibly humble demands. Rather than being asked to flaunt their bodies on a battleship for a big-budget video like Cher once was, they can just act silly in their bathrobe or backyard. Some artists are great at doing that sort of thing. Lizzo seems happy to film herself strutting on a treadmill. Lil Nas X appears addicted to wielding his selfie camera while shirtless. But recently, a crop of established artists has made clear that the platform can be a drag—and that the job of entertaining the masses is changing in exhausting ways.

A popular tweet last month featured screenshots of TikToks in which Halsey, FKA Twigs, Charli XCX, and Florence Welch each alleged that their record labels were nagging them to use the platform more. XCX lip-synched

to audio saying, "I didn't really want to be here" over the caption, "When the label asks me to make my 8th tiktok of the week." With a sigh, Florence Welch sang a song a cappella to fulfill her label's supposed demands for "low fi tik toks." Halsey reported they weren't allowed to release their new single until they'd engineered a viral moment. FKA Twigs said, in a now-deleted video, she'd been scolded for not putting in enough effort on the platform.

Some commenters scoffed at the sight of celebrities carping about the work of being famous. But these artists have hardly been lazy or reluctant to play the music business's games. Each of them is known for elaborate music videos, spectacular stage productions, and otherworldly fashion. They've hustled, for all of their careers, to seem larger than life. Now audiences—or at least the industry that markets to them—want stars to be smaller, more normal. Is there any clearer sign that we live in an age of disenchantment?

A PARADIGM SHIFT IN POP may be happening—and not for the first time. When MTV arose in the early '80s, popularizing the music video as a promotional tool, many people fretted about the deeper effect of music becoming so tied to visuals. In a 1984 *Rolling Stone* essay, the film critic Kenneth Turan wrote of the creation of "a generation of gratification-hungry sensation junkies with atrophied attention spans." (Sound familiar?) Craig Marks

and Rob Tannenbaum's 2011 book, *I Want My MTV: The Uncensored Story of the Music Video Revolution*, quotes the producer Rick Rubin saying, "In some ways, MTV hurt music, in that it changed what was expected of an artist. The job changed. It became a job of controlling your image."

Image, of course, had already been part of pop—ask David Bowie or Andy Warhol. But music videos heightened the tension between revelation and mystique. Landmark clips by Michael Jackson and Madonna centered the telegenic star, inviting crushes and curiosity while also transporting the viewer to another reality—one of zombie dancers or messianic lovers. As decades went on, the format proved itself a modern art form. Whether the example is Sinéad O'Connor's stark montage, Nirvana's sleazy pep rally, or Missy Elliott's CGI wonderlands, the great music videos have been as carefully composed as their songs are.

The internet—coupled with MTV's turn to reality-TV programming—might have seemed likely to kill the music video in the 2000s. But YouTube kept the form vibrant as audiences moved online. Stars such as Lady Gaga and Beyoncé threw back to the ambition of '80s MTV while adding details and micro-moments designed for endless pause-and-replay analysis. As Twitter, Instagram, and Facebook opened new avenues for artists to commune

A

with fans, music-video aesthetics preserved a sense of stars as strange and unreachable (the 2011 MTV Video Music Awards looked like a Halloween party). Even today, as TikTok gobbles up attention, artists continue to treat the music video as a canvas for stylized, imaginative storytelling.

But pop's ideology shifted a bit over the course of the 2010s. The dishy lyrics of Taylor Swift's catalog and perhaps of Beyoncé's last two albums—plus the influence of social media—led the way for stars to become more confessional, more knowable. Olivia Rodrigo's and Billie Eilish's conversational writing styles, for example, project chatting-with-your-bestie intimacy. Today's young stars still create pop-star spectacle with their clothes, stage shows, and, yes, videos. But many of those offerings seem subordinate to revealing documentaries, tabloid-baiting lyrics, and oversharing TikToks.

Glaringly, the prominent artists complaining about record labels demanding TikToks tend to be millennials who love a good music video—or at least seem to appreciate the power of cultivating distance from their listeners. Halsey's last album arrived with a tie-in film that screened in IMAX theaters. Welch's band, Florence and the Machine, has long projected a mystical aura (you can't really imagine her livestreaming from the grocery store). Charli XCX's work tries to revive the archetype of the

highly constructed pop diva. Earlier this year, she temporarily left Twitter because of the toll social media was taking on her mental health.

The most poignant objector to TikTok pressures may be FKA Twigs, an experimentalist in the vein of the MTV auteur Björk. For her excellent January 2022 mixtape, *Caprisongs*, Twigs filmed a slew of gorgeous music videos. (One of them even references TikTok, featuring guerrilla choreography.) She has been sharing clips of those videos on TikTok. But they tend to get a lot fewer views than when she posts jokes about her relationships, a sensitive topic that she has found painful to have scrutinized in the past. In May, a day before she published (then deleted) her complaint about TikTok, she released one of her most-viewed creations of the year: a five-second clip about loving skinny men with mommy issues.

IF TIKTOK MAKES THE music world look and act more banal, it also, in some cases, makes it sound that way too. One fad is songs that take kindergarten-friendly gimmicks—a countdown, a sound effect—and add adult profanity, making for a cocktail of relatability. Gayle's "abcdefu," a Billboard Hot 100 smash, is the sharpest example: It rewrites the alphabet as a snarling breakup note. Tracks such as Bella Poarch's "Build a Bitch" and Leah Kate's "10 Things I Hate About You" have such

view-baiting formulas that they have spurred backlash and parodies.

"Abcdefu" is on trend in another way too: Its origin story has made people question the nature of their reality. Last year, Gayle, then a largely unknown songwriter, had asked her followers for song ideas. One commenter suggested she write a tune based on the alphabet, and Gayle obliged, singing on acoustic guitar from a bathroom. Amazing backstory for a global hit, right? Not quite. Other TikTok creators eventually "exposed" the fact that the alphabet suggestion had come from a marketing manager at Atlantic Records, which had recently signed Gayle. The label told *Newsweek* that the initial TikToks had indeed been made after the song was recorded, as a "playful" in-joke.

Similar stories have played out again and again on the platform: Artists appear to get real, and then their audiences debate whether they've been hoodwinked. Even when Halsey complained about TikTok, viewers speculated that the griping was meant to fabricate the very viral moment that the star's label had wanted. Halsey pushed back against such allegations, only further building intrigue around an unreleased song. The cycle is dizzying and numbing: The allure of authenticity invites fascination and then, inevitably, skepticism. All along, truth and trust aren't celebrated; they're destabilized.

Perhaps the old notion of pop being a home for unapologetic artifice is just evolving. The feed of Charlie Puth, a 30-year-old maestro of radio-ready cheesiness, feels a bit like postmodern performance art. His videos blend abject nerdery (he'll identify the musical tone of everyday sounds), objectification, and promotion so frantically that Puth seems to wobble between actual human being and caricature. For months, he looped viewers in as he built a song around the sound of a light switch being flicked. Was that just a staged ploy to amass hype for a single that was already written? His puppy-dog excitement on camera did not so much answer that question as revel in the extent to which it does not matter.

The purer dream of the music video—a dream of moviemaking supercharging music—does still live in some corners of TikTok. The wonderful indie-pop duo Magdalena Bay have built a following on the platform with a visual aesthetic that matches their musical one: hallucinatory, retro, deadpan, and lovable. Using VHS camcorders and other old equipment, they offer a meta take on TikTok, showing how past generations of televisual technology hypnotized people too. But even so, TikTok's anarchic algorithm isn't reliably keeping the focus on the group's music. One of Magdalena Bay's most-played clips is an explainer about a weird park they found in LA.

The artists complaining about TikToks aren't exactly condemning the platform. But they are showing that

being *on* all the time, influencer-style, takes effort and talent that is different from the kind it takes to perform a great song. Do we really want our entertainers demystified and desperate? Are we too cynical and distracted to enjoy wide-screen musical escapism? Beyoncé, for what it's worth, has not put out a solo studio album since 2016, the year TikTok began. She has an account on the platform, but as of now, she has not posted to it.

THE EERINESS OF THE
DISCO REVIVAL

———————

December 2020

MY ACHES AND CHILLS STARTED on the same day that I'd planned on mingling with strangers to the music of Donna Summer. On March 11, the Brooklyn Museum held an opening party for an exhibit on Studio 54, the iconic '70s nightclub where Bianca Jagger once rode around on a horse led by a naked model. But headlines about the spread of COVID-19 in the US got worse over the course of the day, as did the feelings of physical ickiness that I now know was the onset of a mild case of the virus. I stayed home, and both museums and dance floors soon shut down citywide. Cooped up over the past nine months, the closest I've gotten to the Studio 54 experience has been watching videos about it online. "The music, the sound system, was so calibrated that it would just blow through your body," the veteran party photographer Rose Hartman reminisces in a clip promoting the exhibit. "You just had to start moving."

The notion of such a sound system—and the concerts, clubs, and parties it could power—has come to feel almost mythological this year. On the long list of things thwarted

by the pandemic, the freedom to move our bodies together has not been an insignificant one. You can, in fact, tell its significance because 2020 was not the year that dancing died. It was actually the year of a desperate, passionate, and at times unsettling disco revival.

That revival had been brewing in popular music pre-pandemic. Last winter, Dua Lipa's hit "Don't Start Now" brought the Anita Ward–style laser zap to the Billboard Hot 100. Justin Timberlake and SZA were dancing inside of a mirror ball in the video for the thump-thumping single "The Other Side." The Chic-style guitars of Doja Cat's "Say So" were inspiring groovy moves on TikTok. The strobing synths of Lady Gaga's "Stupid Love" recalled Giorgio Moroder's pioneering production on Donna Summer's "I Feel Love," as did Sam Smith's late-2019 cover of that very song. "It's Studio 54 all over again," a radio programmer marveled to *Billboard* in early March.

Disco, of course, had never fully died. Its musical tropes—the rhythmic heartbeat, the octave-jumping bass, the swooping violins—continually suffuse pop, though they do tend to make themselves more overt every few years. (Remember the summer of Daft Punk's "Get Lucky"?) More important, disco's DNA is essential to all sorts of thriving modern scenes: hip-hop, house, EDM, even country. Probably its biggest legacy was to turn ecstatic public dancing to prerecorded music into a worldwide

pastime and megabusiness. Warehouse raves, bottle-service clubs, and Jazzercise classes all embody the disco sensibility. But if 2020 was shaping up to be a year in which this often-mocked genre's influence was honored, the pandemic seemed sure to stop the party. COVID-19 thrives when crowds press together and freak out.

Yet as dance clubs locked their doors and Americans spent their Saturday nights fevered with thoughts of *Tiger King*, the new-new-disco sound stuck around. Doja Cat's single hit No. 1 on the Hot 100 in the pandemic spring. Later, that spot was taken by BTS's "Dynamite," which featured funky horns and a music video prominently featuring the word *disco*. Take a look at music critics' year-end album lists, and you see the trend everywhere. Dua Lipa's and Lady Gaga's decidedly retro dance albums, *Future Nostalgia* and *Chromatica*, garnered tons of praise. So did Jessie Ware's fantastic *What's Your Pleasure?*, on which the UK singer, known for lush ballads, turned to Paradise Garage–style pulsation. The Irish indie-pop singer Róisín Murphy's new epic, *Róisín Machine*, twitched with kick drum and electric piano. The Australian standby Kylie Minogue rolled out a glittery album titled—get this—*Disco*.

Though some of these albums were recorded before the pandemic, each seemed to cater to listeners' stir-craziness. "We all got wanderlust in the darkest place," Minogue

sang in a single with a chorus that pleaded, "Can we all be as one again?" Live-streams and TV appearances did their best to evoke the feeling of doing the hustle with a sequined crowd. In November, Dua Lipa staged an elaborate online concert called "Studio 2054" in which she, a handful of dancers, and some star guests (including Minogue) sang and shimmied for more than an hour on a tricked-out soundstage. Tickets to watch the stream went for $18.50 apiece; Lipa's team reported that she garnered more than 5 million views worldwide.

But for the fuller picture of disco's enduring significance, look to all the ways that people used the music in 2020. Wherever people broke with social distancing, four-on-the-floor beats seemed to surface. The thumping music of Black Lives Matter protests included disco. So did the rallies of President Donald Trump, which were energized by The Village People. There was also the global trend of "plague raves": illicit dance parties held in underpasses, apartments, and fields. Video of one gathering in the UK shows throngs of maskless young people singing along to "Make Luv," a 2003 disco-house single by Room 5—disturbing footage once you learn of the reported stabbings and rapes British police investigated at such events this year. Here, too, was the story of disco in 2020: willful defiance that did not, try as it might, turn bad times into good times. The genre's history is

one of carefree dancing somehow encapsulating broader tensions—and this year, disco often highlighted the complexity of the mess we're in.

IT'S TELLING THAT THE CAMPY, polyester aesthetics of the 1977 film *Saturday Night Fever* have been baked into the marketing of 2020's disco pop. The movie is much darker than such aesthetics suggest, with scenes of sexual assault, violence, and racism that seem to indict disco culture as nihilistic. The film is also a famous example of musical whitewashing and straightwashing in action. Disco largely arose from Black, Latino, and queer spaces and sounds in the late '60s and early '70s, yet before long, Hollywood could hold up John Travolta and the Bee Gees as the scene's mascots. An underground urban phenomenon had blossomed into mass escapism during a decade of economic crisis and political burnout. But even as straight, white Americans partook of disco's pleasures, the genre still represented diversity, cosmopolitanism, and queerness to many people—and backlash began to brew.

At the infamous 1979 Disco Demolition Night, a white Chicago rock DJ orchestrated the mass destruction of disco records at a baseball stadium. "The message was, *If you're Black or you're gay, then you're not one of us*," the music producer Vince Lawrence, who was working at the stadium that night, recalled in a 2018 documentary. Soon after that, some members of the disco scene went back

underground to engage in the experimentation that would lead to house, techno, and hip-hop. But it wasn't just the "Disco sucks" movement that caused cultural tides to turn. The music industry had begun pumping out generic disco singles of low quality. The nightlife circuits of the late '70s really did encompass unsustainable excess, as seen in the saga of Studio 54, a temple of sex and drugs that eventually got busted for (of all things) tax evasion. HIV/AIDS also began to rip through disco's original constituencies and tamp down the feeling of sexual freedom that pulsed through nightlife.

In a strange way, the 2020 disco wave both echoes and inverts some of the social dynamics that fueled the mid-to-late-'70s craze: Pop's current obsession may well be a backlash to surging Black music. As rap and R&B became the most popular American genres in the 2010s, some of the most titanic figures in pop, mostly white ones, were left without a clear playbook for world domination. The ever more pummeling, EDM-influenced trajectory of Lady Gaga types in the early 2010s certainly stalled out. Reaching for disco—and its descendant rave-inspiring subgenres—may appear to be a safe bet for a sonic reset. Its 2020 form is a rhythmically steady and widely appealing sound that suits both workouts and chillouts, which is to say it fits in the flow of many different playlists. It is a close enough relative of hip-hop that it doesn't seem out of touch, but it is also a refuge for listeners unenthused by

modern rap. Throw in the way that the pantomime dances of TikTok resemble the hammiest disco moves, and the logic of a revival feels inevitable.

To be sure, a diverse set of performers has landed disco hits in 2020. But glaringly, the stars who went all in on disco albums this year were white women (Lipa, Gaga, Ware, Minogue, Murphy), many of them working with white production and songwriting teams. In February, a Dua Lipa fan caused a mini controversy on Twitter by thanking his diva for "reviving disco music in an era where white artists try to move to trap and hip hop in the hope of being more successful." The presumption in the tweet—that disco is a purer, whiter music—was both ahistorical and racist, yet it also seemed to articulate a subtext of the 2020 disco wave. When Black Lives Matter protests flared up across the country this year, they led to soul searching within the music industry over the ways that white artists have so often profited from Black innovation. A clear example, to anyone paying attention, seemed to be unfolding in pop's latest fad.

The artists involved seemed to recognize this as an issue—but only after they'd recorded their albums. Gaga's house-and-techno-indebted *Chromatica* was released days after the death of George Floyd; recognizing that it wasn't the time for her to grab the spotlight, Gaga temporarily suspended her promotional efforts. Ware also pushed her June release date back a bit. Both women, when they did

return to advertising their albums, acknowledged the historical lineages and racial hierarchies they benefited from. "All music is Black music," Gaga said in a *Billboard* article. Ware told *Gay Times*, "Everyone knew disco, but I didn't fully understand the significance of it as a genre for the queer community and the Black community as much." Remixes, music videos, and social media activity by these artists did end up giving a platform to Black voices—but those efforts could not change the fact that the albums they promoted were, in the first place, not very inclusive documents.

THIS CONTEXT COMPLICATES THE easy narrative being marketed with 2020 disco: the notion that "disco has that sense of joy that people need when things are really going to shit at the moment," as Ware put it. She's surely right, but the quest for pleasure that denies the reality of its moment can sometimes amount to moral or social disengagement. Note how rhetoric about struggle and escape has been common in the justifications of people attending potential super-spreader parties. PERSEVERANCE read a banner waving at a large rave beneath a New York City bridge in August; one of the event's unapologetic organizers told *Gothamist*, "People need a release." Populations of all stripes have violated social-distancing guidelines over the course of the year, but certain demographics are more likely to pay the cost for recklessness. As the DJ Harold

Heath wrote in *Attack* magazine, "Let's not forget that while these DJs play music of Black origin, this is a pandemic that is disproportionately killing Black people."

None of this is to say that the disco pop of 2020 endorsed irresponsibility or sounded cynical. Really, the songs didn't so much distract from the state of the world as cast a new light on it; with introspective lyrics, they honored the disco tradition of simple choruses that hit like an epiphany. Listen closely to *Chromatica* and you'll hear Gaga reckoning with panic and trauma on a surprisingly vulnerable level. One Róisín Murphy mantra about life's monotony that almost made me sob during a masked run this summer: "Keep waking up at 6 a.m. / Getting up, doing it *allllll* again." I also became obsessed with *Club Future Nostalgia*, a remix album in which the DJ The Blessed Madonna brought in a cast of dance-music producers to rework Lipa's songs into a chaotic, nonstop groove. On the closing track, the Detroit techno mainstay Moodymann turns one of Lipa's hit choruses—"I would have stayed at home"—into a poignant, swirling, pandemic-appropriate wisp of a thought.

Such close listening was invited by the music itself. In most cases of 2020 disco pop, artists prized richness and intricacy as they fit vintage signifiers into sleek modern templates. The production team for *Future Nostalgia* repurposed some of the corniest tropes from dance music throughout the decades—fusing Studio 54 gimmicks

with macho '80s guitars and 2000s melodic math—for a radically sincere head rush. This was also the approach of Gaga's crew with *Chromatica*, though they were more focused on '90s rave culture. The most transporting album of the bunch was Ware's *What's Your Pleasure?*, whose keyboard sizzles and drum thwacks seemed coated in a mix of glitter and cobwebs. Ware's music immediately transforms any room into a more elegant place.

But possibly the best disco-pop track to come out of this moment is "Experience," a single from the EP *Jaguar* by the rising R&B singer Victoria Monét. Amid a thicket of rippling keyboards, Monét sighs, "I'm hoping experience will get you to change." A wish for mishaps to lead to better times: That's a nice New Year's thought. Moreover, the song sounds so confident, modern, and enveloping that it's easy to forget how retro its influences are. In the video, three friends skate around a purple-lit roller rink that's otherwise empty. They look like they're having fun, but not too much fun, and as you watch you might get a very 2020 feeling: the desire to enjoy this song in a crowd, and the awareness that the time to do so has still not arrived.

ARTICLE CREDITS

ABOUT THE AUTHOR

SPENCER KORNHABER is a staff writer at *The Atlantic*, where he covers music and popular culture. Prior to joining *The Atlantic* as an editor in 2011, he was a staff writer at *OC Weekly* and a freelancer for *Spin* and *The A.V. Club*. In 2019, he won the Excellence in Column Writing Award from NLGJA: The Association of LGBTQ Journalists.